IMAGES
of America

WEST ESSEX
ESSEX FELLS, FAIRFIELD,
NORTH CALDWELL, AND ROSELAND

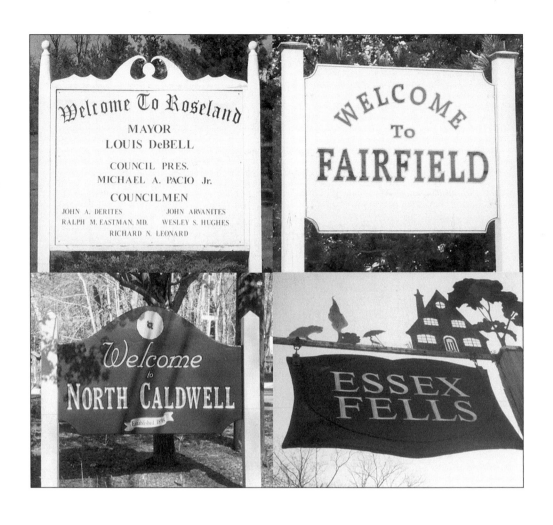

Cover image: This photograph, c. 1928, shows Boy Scout Troop One camping out in the woods behind the Presbyterian church on Freeman Street in Roseland. Out front is Herbert Robinson. Other members, from left to right, are as follows: (front row) Charles Rudolph, George Flammer, John Heath, unidentified, Gordon Robinson, Robert Greer, and Bill Giltzow; (back row) Clifford Robinson, Robert Palen, Jack LaForce, Harold Heath, Rex Martin, and Carl Ingerking. (Photographer: William Hunstman, pastor, Roseland Presbyterian Church, courtesy Everett Leonard, Roseland Historical Society.)

IMAGES
of America

WEST ESSEX
ESSEX FELLS, FAIRFIELD, NORTH CALDWELL, AND ROSELAND

Charles A. Poekel Jr.

ARCADIA

Published by Arcadia Publishing,
an imprint of Tempus Publishing, Inc.
2 Cumberland Street
Charleston, SC 29401

Printed in Great Britain.

Library of Congress Catalog Card Number: Applied for.

For all general information contact Arcadia Publishing at:
Telephone 843-853-2070
Fax 843-853-0044
E-Mail arcadia@charleston.net

For customer service and orders:
Toll-Free 1-888-313-BOOK

Visit us on the internet at http://www.arcadiaimages.com

This book is dedicated to my parents, Alice and Charles Poekel, who taught me from an early age the importance of history and instilled in me a love of the past, respect for those who went before us, and the desire to preserve precious memories.

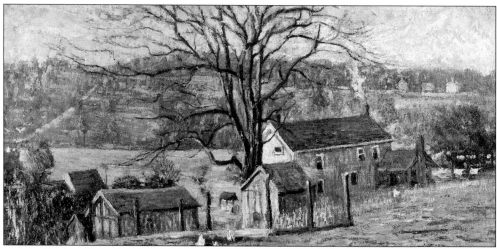

This is the Sandford-Stager home, as portrayed in an early 1900s oil painting by artist Ernest Lawson, who lived in the house. Located on Grandview Avenue in North Caldwell, the home was also at one time the residence of Richard Wilbur, Pulitzer Prize winner and poet laureate of the United States. In 1998, the house was threatened with demolition. At the urging of the North Caldwell Historical Society and many concerned citizens, the Borough of North Caldwell purchased the house for it to always remain as a historical reminder of how things were in old North Caldwell. (Ernest Lawson (1873–1939), Watkins Farm, North Caldwell, 1906, Oil on canvas, 24-1/4X30-1/4 (61.6 x 76.8), Photograph reproduced with the permission of the Montclair Art Museum, Montclair, New Jersey, Permanent Collection of The Montclair Art Museum, New Jersey, Gift of Dr. S.C.G. Watkins, 1937.22, Photo credit to Jean Lange.)

CONTENTS

ACKNOWLEDGMENTS

I wish to thank the following individuals who most generously gave their time, encouragement, and resources to help bring this book about: Angelo Stosi; Dr. Beverly Crifasi; Mayor Louis DeBell of Roseland; Everett Leonard; Kitty Wick; Charles Vanyo; Roxanne Douglas; Sal and Rose Passafaro; Lisa Pasternak; Mayor Muriel Shore of Fairfield; Mayor Anne Whitehead of Essex Fells; Gregory Schwalenberg, Director of the Babe Ruth Birthplace and Museum; Sharon Farrell, Curator of the Grover Cleveland Birthplace; Lori Barnes, Administrator of the Caldwell Public Library; Mayor James Matarazzo of North Caldwell; Geroge Kamper, photographer; Richard K. Cacioppo; Dianne Hagen, Archivist of the Carrier Corporation; Joshua-Lynn, photographer of Broadway Photo; and Douglas Coleman, Esq. of the Curtiss-Wright Corporation.

I want to particularly thank Harold Peer, Mary and the late James Lebeda, Robert Bush, John J. Collins, Woody Walker, Mary Lou Dee, William B. Pryor, Jack Gordon, Esq., George Rosewall, Eugene Straub and his wife Maryanne Straub for sharing with me the wonderful photographs from their private collections. Also, special thanks to Caroline Medina for sharing her marvelous Essex Fells painting. No book like this could come to fruition without the resources of institutions and corporations, and I want to thank the Montclair Art Museum, the Roseland Historical Society, the North Caldwell Historical Society, the New Jersey Historical Society, the Newark Public Library, the Roseland Public Library, the Babe Ruth Birthplace and Museum, Baltimore, Maryland, the Caldwell Library and its Local Historical Collection, the West Caldwell Historical Society, the West Essex Regional High School, the Horse Neck Founders and Genealogy Society, Inc., the Grover Cleveland Birthplace Association, Technical Photo, Inc. of Fairfield, New Jersey, the Borough of Essex Fells, Curtiss-Wright Corporation, the Fairfield Historic Society, and the State of New Jersey.

Finally, I want to thank Heather Gonzalus, who as editor of the book always steered me in the right direction, and a very special thanks to Charles A. Poekel III, William Poekel, and Patty Poekel, who gave up so much of their time with their Dad in order for this book to come about.

INTRODUCTION

Originally, Essex Fells, Fairfield, North Caldwell, and Roseland were all part of the original Township of Caldwell. These land areas were involved in the February 16, 1798 act of the New Jersey Legislature that created Caldwell Township from the townships of Newark and Acquackanonk. The original Caldwell Township was over 50 square miles in size. Eventually, the township was divided into individual boroughs. In 1898, the Borough of North Caldwell was created by an act of the state legislature. In 1902, Essex Fells was carved out of the territory. Roseland was set up in 1908 out of a part of the Township of Livingston, which itself had been part of Caldwell Township. The four western Essex communities were rejoined for the first time in 1962 when the West Essex Regional School District was formed. These towns form a circle around Caldwell and West Caldwell. However strong their bonds might have been in the past, the four towns have developed their own unique identities over the years.

This book provides a pictorial essay using photographs that, for the most part, have never before been published. The purpose is not to satiate the readers but rather to whet their appetite for more information and research on these unique communities. The chapters that follow roam through life as it was in earlier times, from the farms of Fairfield to the estates of Essex Fells and from the naturalness of North Caldwell to the residences of Roseland.

The Early History of West Essex

Thousands of years ago, dinosaurs roamed the area we now call West Essex. Fossils of these creatures have been found in Roseland. The first human inhabitants to occupy the land located between the Second Watchung Mountain and the Passaic River were Native Americans of the Leni Lenape tribe.

In 1701–02, a group of British colonists purchased from the Native Americans an area of land known as the Horseneck Tract. The exact origin of the name has been lost, but it was common in those days to give the term "neck" to any strip of high ground between two bodies of water. The colonists paid $325 for the 13,500-acre tract (now West Essex)—quite a high price compared to the $24 paid for all of Manhattan Island some 75 years earlier.

In the 18th century, with New Jersey divided between the East and West Proprietors, land disputes developed with those tracing their deeds to the Native Americans. One of the first disputes arose in Fairfield in September 1745, when the Essex County sheriff arrested three Horseneck woodchoppers as squatters. Neighbors broke into the Newark jail and freed the woodchoppers. Then, a militia was organized to challenge the authorities. The Horseneck Riots represented a challenge to the Crown 30 years before Lexington and Concord.

In 1806, an estimated one third of the total population of Horseneck were cobblers. In those days there were no left or right shoes, and shoes were purchased one at time. Children were

cautioned to switch shoes every day. Shoes were made for Revolutionary soldiers, which helped them win the war. During the Civil War, the West Essex cobblers continued to supply shoes for the Union army. It was not until the Industrial Revolution took place that shoemaking ceased as a primary activity in West Essex.

Two Revolutionary War officers were from West Essex: Capt. Nathaniel Gould from South Caldwell, now Essex Fells, and Jonathan Condit from Verona. Tories also were residents: Caleb Hatfield from Fairfield and Peter Riker, who lived close to the Roseland line on a craggy hill which was later named after him.

Roads as we know them did not exist until automobiles came into use. Then, trails and paths turned into highways. The first road coating, invented by a Scotsman named MacAdam, covered the Newark-Pompton Turnpike. King Crane constructed Bloomfield Avenue in 1856. Bloomfield Avenue was the Big Road; Passaic Avenue was Swamp Road; Beaufort Avenue was Featherbed Lane; Livingston Avenue was Dark Lane or North Midway; and Eagle Rock Avenue was Swinefield Road.

The history of West Essex is intertwined with the establishment of churches, which presented both a religious and social focal point for their communities. Those churches were the Dutch Reformed and the Methodist in Fairfield, the Methodist and Presbyterian in Roseland, St. Peter's and Calvary in Essex Fells, and Notre Dame and Church of Latter Day Saints in North Caldwell.

Bibliography

Amero, Richard W. *Madame Schumann-Heink: A Legend in Her Time*. Unpublished manuscript.

Bailey, Rosalie Fellows. *Pre-Revolutionary Dutch Houses and Families in Northern New Jersey and Southern New York*. Dover Publications, New York, 1936.

Becker, Henry E. "Centerville & Southwestern Railroad." Live Steam Magazine, February 1974.

Brydon, Norman F. *The Essex Fells Story—1902–1977*. The Borough of Essex Fells, N.J., 1977.

Brydon, Norman F. *The Passaic River—Past, Present, Future*. Rutgers University Press, New Brunswick, N.J. 1974.

Bush, Robert. *A Small House in New Jersey*—The Harrison House in Roseland and the Family Who Lived There—Williamses, Harrisons, and Teeds, 1824–1976. The Roseland Historical Society, Roseland, N.J., 1993.

DeBaun, Roscoe. *Country Life in Fairfield, New Jersey from 1887 to 1909*. The Etude Music Magazine, Philadelphia, January 1934.

Flammer, Kaas, Lincoln, Leonard, Birsbane and Fardelmann. *Centreville, Roselyn, Roseland—The History of a Community*. Borough of Roseland Bicentennial Committee, Roseland, N.J., 1976.

Folsom, Fitzpatrick, and Conklin. *The Municipalities of Essex County New Jersey 1666–1924*. Lewis Historical Publishing Company, New York, 1925.

Lockward, Lynn G. *A Puritan Heritage. The First Presbyterian Church in Horseneck*. Caldwell, N.J., 1955.

MacNab, J.A. *Song of the Passaic*, New York, 1890.

Norwood, Benjamin Robert. *Old Caldwell—A Retrospect, 1699–1926*. Caldwell Publishing Co., Caldwell, N.J., 1926.

Rybczynski, Witold. *A Cleaning in the Distance. Frederick Law Olmsted and America in the Nineteenth Century*. Scribner, 1999.

Shaw, Frederic. *Little Railways of the World*. Howell-North, Berkeley, California, 1958.

Shaw, William H. *History of Essex and Hudson Counties, New Jersey*. Everts & Peck, Philadelphia, 1884.

One
ESSEX FELLS

The 1870s and the 1880s saw substantial growth in land development. Among those developers who spotted an opportunity where train travel ran was Anthony S. Drexel of Philadelphia, who had developed much of the land located along the main line of the Pennsylvania Railroad outside of Philadelphia. When he heard that train travel was to be extended from New York City to the Caldwells, Drexel sent Charles W. Leavitt to investigate. Leavitt helped organize the New York Suburban Land Company. John F. Fell, a son-in-law of Drexel, was a majority stockholder. In 1898, the corporation purchased approximately 1,000 acres from the estate of Gen. William J. Gould. In deciding upon a name, the group chose Essex, after the name of the county and for its English overtones, and Fells, the plural of John Fell's name and also the name for a down or hill. Ernest W. Bowditch, a well-known landscape architect, was retained to lay out the concept of the community. When hard times befell the Suburban Land Company, the enterprise came under the direction of the Drexel estate, still with Leavitt in charge. The New York real estate firm of Wendell & Treat was commissioned to market the properties. Early Essex Fells residents desired the benefits of a separate community, especially a school. Therefore, in 1901, their leaders petitioned the New Jersey State Legislature for incorporation. On March 31, 1902, the petition was approved and the borough came into existence. Today, Essex Fells is the smallest community in Essex County, with a population of approximately 2,500 and no traffic lights.

ESSEX FELLS,

(PROPERTY OF THE NEW YORK SUBURBAN LAND CO.)

ESSEX COUNTY. - - **CALDWELL,** - - NEW JERSEY.

UNDER THE PATRONAGE OF

Mr. JOHN R. FELL, of Philadelphia.

"One of the Three Healthiest Places in the United States."

THE NEAREST MOUNTAIN DISTRICT TO NEW YORK CITY.

A FINE WATER SUPPLY AND THE MOST APPROVED MODERN SYSTEM OF SEWERAGE.

Address, C. W. LEAVITT, *President N. Y. Suburban Land Co.,*

or JOHN P. SCHOLFIELD, Secy. and Treas., No. 171 Broadway, New York City,

2nd National Bank, Hoboken, N. J. or Caldwell, N. J.

Unlike the other West Essex communities, Essex Fells was largely developed by a single developer: the New York Suburban Land Company. This cover page from the initial offering touted the mountain location and the fine water of Essex Fells. John R. Fell, whose name was to become part of the borough's name, was in charge of development. He died at age 38.

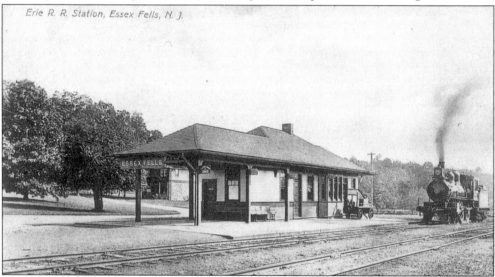

Erie R. R. Station, Essex Fells, N. J.

The railroad helped to market the homes of Essex Fells. In this late-19th-century photograph, the steam engine is shown approaching the station after turning around on the turntable. This view shows the smaller second of two stations, which were used. The first station was designed by Bradford Gilbert and consisted of a two-story English cottage-style building. The station served as the first land company's real estate office, housed the post office at one time, and was used for church services from 1893 to 1896 prior to the construction of St. Peter's Episcopal Church. In the late 1890s, the station was moved to Oak Lane, where it became a private residence.

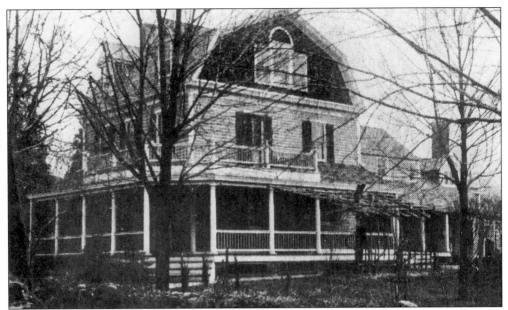

C.W. Leavitt took up residence at the former home of Gen. William J. Gould in order to be firmly located at the center of the new community. This photograph shows the Gould residence as it looked in the 1800s. It is located at the corner of Roseland Avenue and Forest Way. The Gould farmstead included much of Essex Fells. Gould fought in the American Revolution and was made a general in the War of 1812.

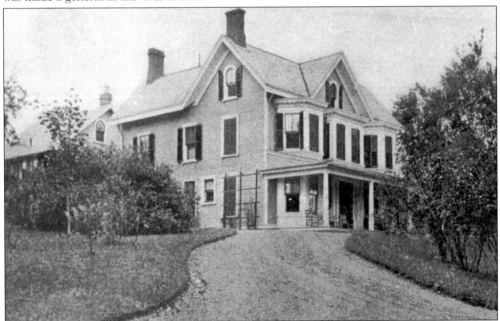

During the late 1890s, as Caldwell became a popular resort, an Englishwoman named Martha Mays established The Lodge and Annex on Welsh Road. The boardinghouse had 20 rooms and provided its guests with delicious meals. Several guests who stayed at the boardinghouse became so enamored with Essex Fells that they bought property and built homes in the nascent community. (Caldwell Library Local Historical Collection.)

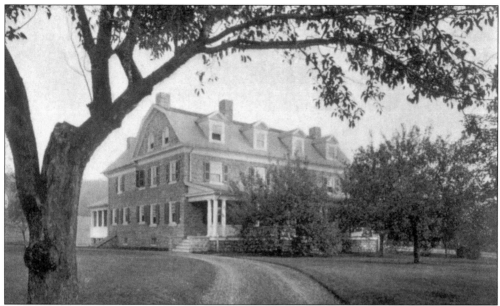

This magnificent house was built originally for J. Brinton White and is situated at the corner of Roseland Avenue and Forest Way, directly opposite the Gould home. In showing this home in its solicitation brochure, the Suburban Land Company stated that it "should be understood by the intelligent home-seeker that Essex Fells is not a land speculation, but a genuine well-planned suburban development" and that it will be "unexcelled in beauty and desirability."

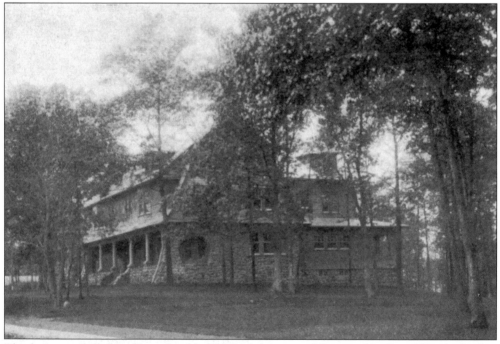

This home was billed as a "comfortable Old English cottage." Designed by David Knickerbocker Boyd, the house had 18 rooms, 3 baths, steam heat, and a price tag of $15,000. It was one of the first offerings by the Suburban Land Company.

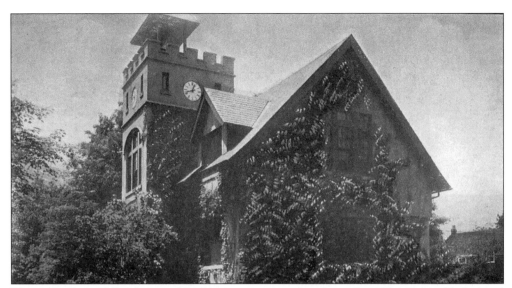

This is the Essex Fells Municipal Building as it appeared in the early 1900s. Originally designed by architect Michael Stillman, it opened in 1913. The building was memorable because only after construction began was it realized that Stillman had made no provision for stairs. A wing was added in 1968 in accordance with the plans of James Timpson of Essex Fells. Timpson, a Yale graduate and architect with 65 years experience, designed many of the fine homes in the community, as well as an addition to the Essex Fells Grammar School. (Caldwell Library Local Historical Collection.)

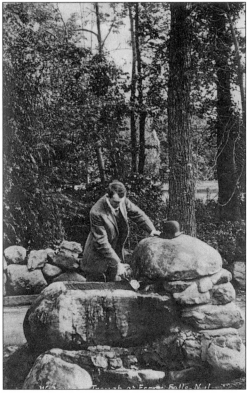

This late-1800s photograph shows the watering trough, which still exists to this day, opposite the fire department on Roseland Avenue. Horses were lead here to drink water which was supplied by the adjacent brook. This watering hole was conveniently located about halfway between Caldwell and Centreville (now Roseland). It is believed that this horse trough is one of the last ones remaining in this country. (Straub Collection.)

This early-1900s view, looking east from the railroad station, shows the residence of Col. J.C. Springg, located on Wootton Road directly across from the town green. The railroad contributed much to the early development of Essex Fells. After decades of effort to make this location more accessible, trains connected the community to Philadelphia and New York. (Straub Collection.)

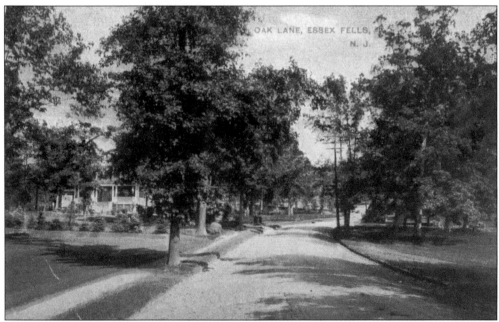

This early-1900s postcard of Oak Lane shows the bucolic nature of Essex Fells. The sole industry of Essex Fells is the Essex Fells Water Company, which supplies water to Caldwell, Verona, and other nearby boroughs. Underground streams of very pure water were located early, and many wells were drilled. The water from these wells is pumped into large mains, which, under sufficient pressure, distribute it to the surrounding towns. (Straub Collection.)

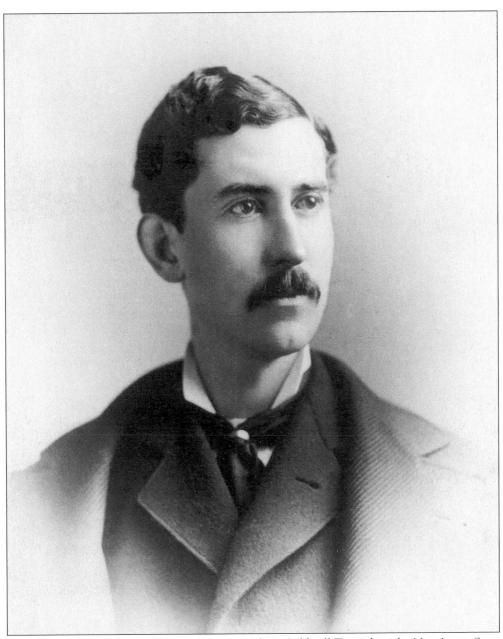

After community leaders petitioned to separate from Caldwell Township, the New Jersey State Legislature approved the incorporation of Essex Fells on March 31, 1902. The borough was born. On May 2, 1902, an organizational meeting took place in a private residence, and Irving P. Boyd, seen above, took the oath of office as the first mayor of Essex Fells. Also sworn in at that time were Councilmen Eugene A. Benjamin, Joseph A. Davidson, Henry Rudolph, John P. Scholfield, John H. Speer, and George E. Weyl. Arrangements were made to conduct council meetings at the railroad station, the location used until 1914 when the borough hall was completed. On July 14, 1902, the council passed an ordinance that specified that "no dog, whether male or female, shall be allowed to run at large without a license tag affixed to a strap or collar around the neck." (Borough of Essex Fells.)

15

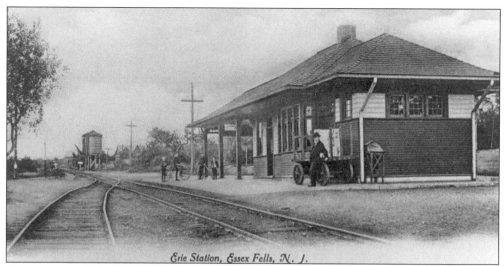

Erie Station, Essex Fells, N. J.

This is one of the earliest photographs of the Essex Fells Railroad Station. It shows the station as it looked shortly after it opened in 1892, one year after service was commenced to Caldwell. The land on which the station was built had been owned by Theodore V.A. Trotter, a shareholder in the Roseland Railway Company, which built the station and line. After suffering financially, both the Caldwell and the Roseland Railway Companies were taken over by the Erie Lackawanna Company. This railroad station was the second station. (Straub Collection.)

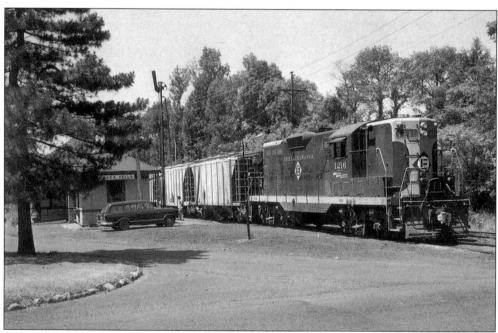

This photograph shows a diesel engine pulling freight past the Essex Fells station in 1965. Passenger service was discontinued on October 3, 1966. Freight service continued until February 1976, when all train service ended. The mayor and council then petitioned the State Public Utilities Commission to have Erie Lackawanna remove the station and fill in the turntable pit. (Straub Collection.)

16

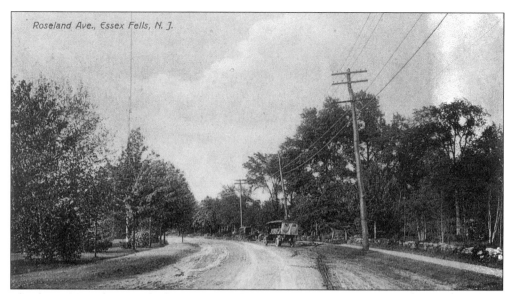

Roseland Ave., Essex Fells, N. J.

This late-1800s photograph shows Roseland Avenue. Much of Essex Fells had been the farm estate of the late Col. Nathaniel G. Gould. This property was transferred to the heirs, grandsons of William Gould, including William and George. General Gould served with General Lee in the Whiskey Rebellion of 1794, earned an excellent reputation for integrity and ability, and fought in the Revolutionary War battles of Springfield and Monmouth. He was a member of the New Jersey Legislature from 1805 to 1817.

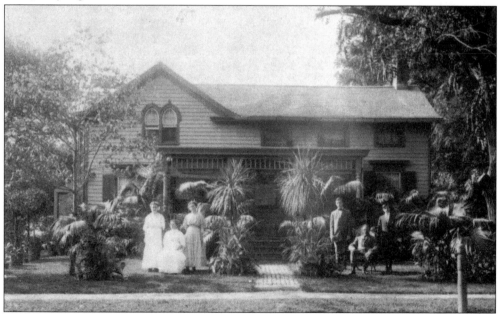

This early-1900s photograph shows Henry Rudolph and his family outside of their home, located at 313 Roseland Avenue. Rudolph ran a florist shop, one of the very few allowed in Essex Fells. In 1928, the borough council passed an ordinance that outlawed any new retail businesses in the community, thus insuring the residential purity of the town. At that time the only other businesses besides Rudolph's were an oil and gas station on Wootton Road and a dress shop on Chestnut Lane.

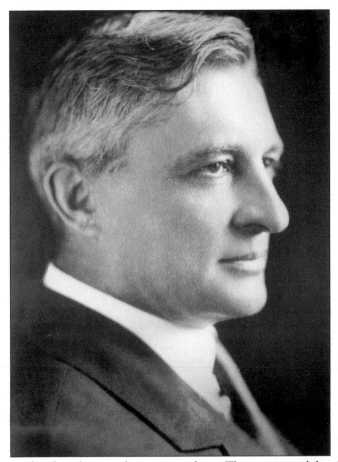

On July 17, 1902, the idea of air-conditioning was born. The creator and developer of that idea was Willis Haviland Carrier, seen above, who made his home in Essex Fells in the 1920s and 1930s. Carrier was born in Angola, New York, on November 26, 1876. He attended Cornell University as a scholarship student, graduated in 1901, and went to work at the Buffalo Forge Company. There, he was faced with the challenge of designing a system to control the humidity in the Sackett-Wilhelm Lithographing plant in Brooklyn, New York. The company had a problem with colors because paper is a hydroscopic material. Carrier successfully created a system to cool the air, control the humidity, and provide for proper air motion and ventilation. Starting with the Palace and Iris Theaters in Houston, Texas, in 1924, Carrier revolutionized the movie business by providing air-conditioning. By 1930, more than 300 movie theaters in the country were air-conditioned by Carrier. During his lifetime Carrier obtained some 80 patents for air-conditioning and founded the Carrier Corporation, which still has a major role in air-conditioning the world. Carrier died on October 9, 1950, in Syracuse, New York. *Time* magazine recently listed Willis H. Carrier among the top 100 titans of industry and inventors of the 20th century. This is what *Time*'s Molly Ivins had to say of Carrier: "If it weren't for Carrier's having made human beings more comfortable, the rates of drunkenness, divorce, brutality, and murder would be Lord knows how much higher. Productivity rates would plunge 40% over the world; the deep-sea fishing industry would be deep-sixed; Michelangelo's frescoes in the Sistine Chapel would deteriorate; rare books and manuscripts would fall apart; deep mining for gold, silver, and other metals would be impossible; the world's largest telescope wouldn't work; many of our children wouldn't be able to learn; and in Silicon Valley, the computer industry would crash." (Carrier Corporation.)

Certificate of Registry

Reg. No. 127

Dr Buckley,
38378

193........

DATE **MAY 23 1936** 1936

June 6

THIS IS TO *CERTIFY* THAT THERE HAS BEEN ENTERED IN THE DOG REGISTER OF THE
............**ESSEX FELLS, N. J.**.................... THE REGISTRATION OF ONE DOG OWNED

BY *Mr Carrier*............

RESIDING AT................................FOR WHICH REGISTRY I HAVE RECEIVED

THE SUM OF *$1.00*........DOLLARS.

NAME AGE *12*..... BREED ...*Setter*... SEX *Male*.. COLOR *W & liver*

EXPIRES ...*June 1*................. 193*7*..... ...*Chief Mull—*............... CLERK
Sgt Paull—

The requirement established by the first mayor and council in 1902 to have every dog licensed was clearly followed by Willis Carrier in 1936. It is not clear whether Carrier ever licensed his cow, whom longtime residents remember wandering through neighboring properties. (Carrier Corporation.)

This photograph shows the house on Rensselaer Road that was the residence of Willis H. Carrier. Carrier lived in Essex Fells with his third wife, Elizabeth. He moved from Essex Fells to Syracuse, New York, where he spent the rest of his life. He was a gentle, unassuming man who was extremely practical. He once said, "I fish only for edible fish and hunt only for edible game—even in the laboratory."

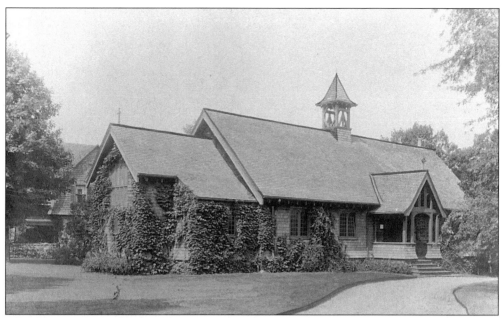

This photograph shows what is now the chapel of St. Peter's Episcopal Church. This church was the first to be erected on land donated by developer Anthony S. Drexel. The building was constructed in 1896, and an addition was built in 1916. The church was originally known as All Saints Episcopal, and worship services were initially held at the railway station. St. Peter's was the first of its denomination to be founded in West Essex and for several years was served by the rector of St. Agnes in Little Falls.

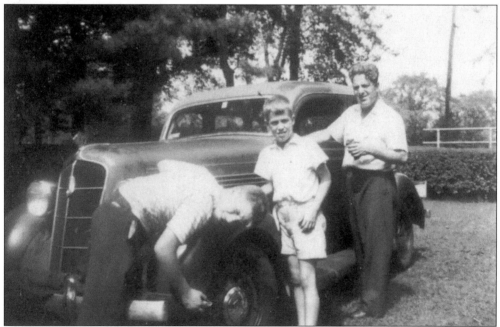

With other than holy water, the Rev. Harold Underdonk and his two sons, Alex and Hal, wash the family car in Essex Fells. Underdonk was rector at St. Peter's Episcopal Church for over 35 years, beginning in 1930. (Robert Bush Collection.)

This photograph shows the "Carpenter Shop" located near the railroad trestle on Runnymede Road in which materials were stored and workshops existed during the early years of construction of the homes in Essex Fells. It later became the Essex Fells Plumbing and Heating Co., an electronics firm which performed pioneer research in the use of stereophonic sound and then the West Essex Unit of the American Red Cross. Today it is the headquarters of the Summit Globgal Partners insurance brokerage firm. (Newark Public Library.)

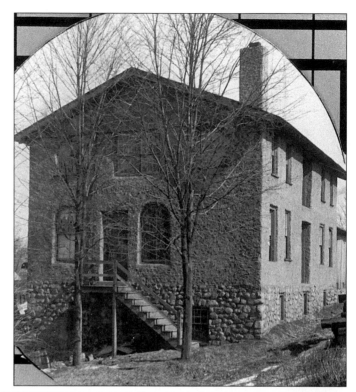

This picture shows Ye Olde Forge, which in 1926 became James R. Marsh & Company, makers of elaborate pieces of wrought iron. Besides making ornamental ironworks, such as chandeliers and wall plates, the Marsh forge manufactured the gates to Sarah Lawrence College. One of Marsh's famous relatives was Reginald Marsh, the world-renowned artist. In the forge, Ann Steele Marsh had an artist's studio and the family held art exhibits and concerts, bringing in local artists on a periodic basis.

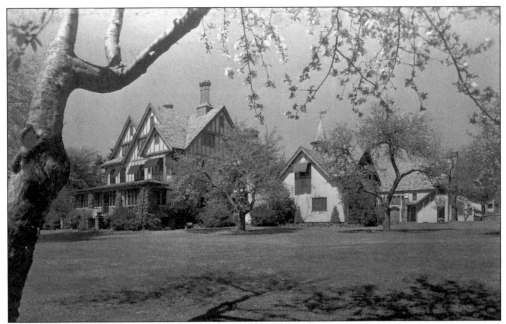

One of the most magnificent estates in Essex Fells was Lenfell, the estate of Leonard and Alice Dreyfus. Dreyfus was the head of the United Advertising Company and a major charitable benefactor. He and his wife were strong supporters of the Newark Museum, which named its planetarium in their honor. (Robert Bush Collection.)

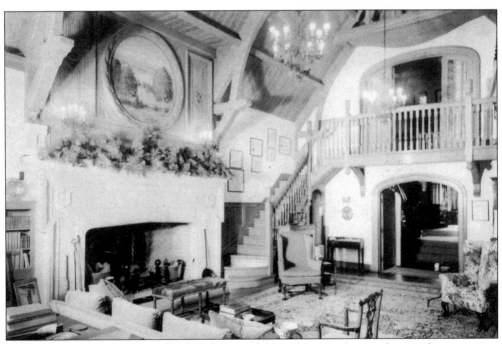

The main living room of Lenfell exhibits some of the architectural magnificence that went into this gorgeous estate. In 1945, Leonard Dreyfus served with distinction as New Jersey's director of civil defense. (Robert Bush Collection.)

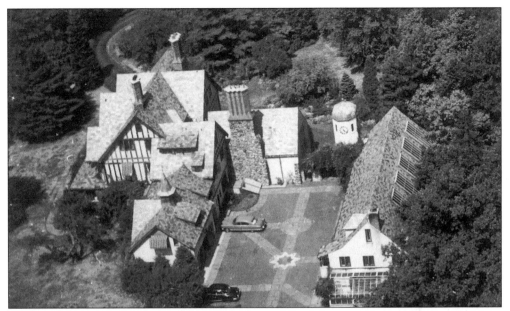

An aerial view of Lenfell shows the majesty of a royal English estate. Across the courtyard from the main house was a building which contained a full-scale gymnasium. This photograph was used as a Christmas card by Leonard and Alice Dreyfus in the 1940s. (Robert Bush Collection.)

This structure located on Chestnut Lane housed Mrs. Balt's Candy Store, which was frequented by students from the nearby Kingsley School. It later served as a dress shop and a beauty parlor before becoming a residence in the 1930s. It is currently the residence of the author. (Caldwell Library Local Historical Collection.)

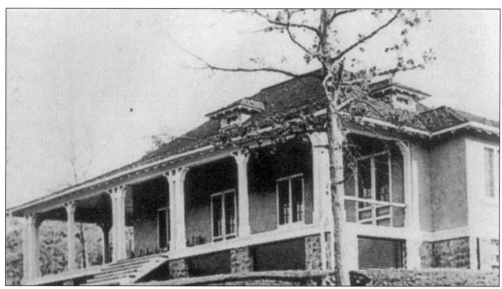

Besides good air, rail transportation, and beautiful landscaping, the developers of Essex Fells wanted a golf course. The first golf course consisted of nothing more than the farmland located along Roseland Avenue to the east. In 1896, a small group of enthusiasts gathered to play on a rough layout of the nine holes. At the suggestion of Charles W. Leavitt, a formal nine-hole course was designed and constructed. In 1906, the club changed its name to the Essex Fells Club and opened its first clubhouse on Hathaway Lane. This photograph shows the club's front entrance.

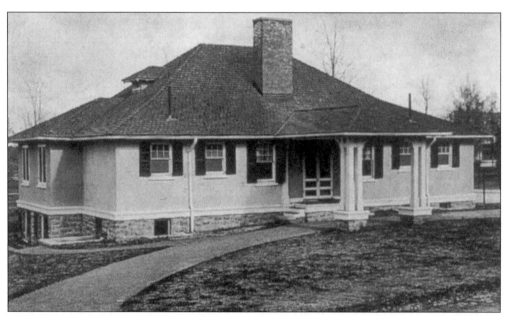

This photograph shows the back of the original clubhouse. The clubhouse, which had a ballroom and wide porches, hosted many dances, lawn parties, and other social events.

The golf club's name was changed to Essex Fells Country Club in July 1915. A full 18 holes opened for play in 1916. The Hathaway Lane clubhouse was sold, and the members assumed temporary residence at this house on the corner of Oval and Oldchester Roads. This building served as the clubhouse from 1914 until 1917.

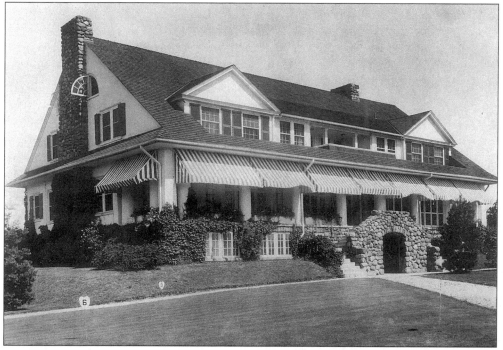

This photograph shows the Essex Fells Country Club as it appeared in 1924. The same club, with several additions and renovations, continues to provide golf and social activities on Devon Road (formerly Golf Road).

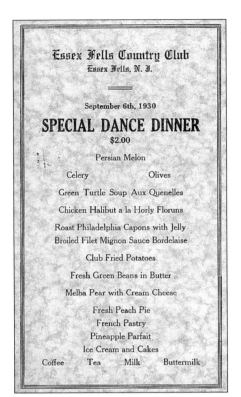

Essex Fells Country Club
Essex Fells, N. J.

September 6th, 1930

SPECIAL DANCE DINNER
$2.00

Persian Melon

Celery Olives

Green Turtle Soup Aux Quenelles

Chicken Halibut a la Horly Floruns

Roast Philadelphia Capons with Jelly
Broiled Filet Mignon Sauce Bordelaise

Club Fried Potatoes

Fresh Green Beans in Butter

Melba Pear with Cream Cheese

Fresh Peach Pie
French Pastry
Pineapple Parfait
Ice Cream and Cakes
Coffee Tea Milk Buttermilk

After the 1929 stock market crash, the Essex Fells Country Club fell on severe economic times. Greens fees were sliced to $2, which was the same price as this special dinner-dance.

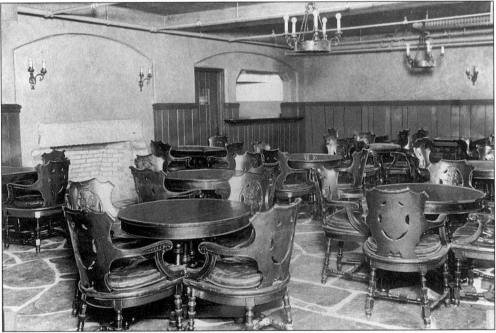

In the late 1920s, the Essex Fells Country Club seized the opportunity to purchase chairs and tables for its grill room when the Waldorf-Astoria Hotel moved from its former location on 34th Street in New York City to make way for the Empire State Building. This photograph, *c.* 1929, shows the grill room with the newly acquired furniture.

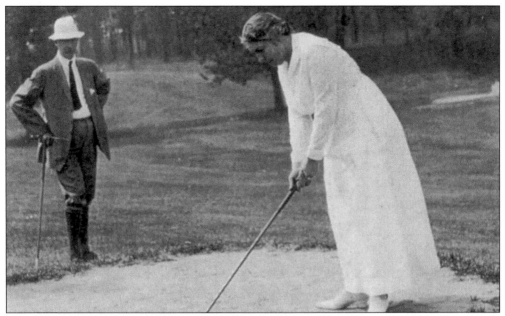

Col. Louis Annin Ames and his wife are shown playing golf in this early 1900s photograph. Ames was the owner and president of Annin & Co., the world's oldest and largest flag manufacturer. The company began inauspiciously in the 1820s in downtown New York City, making signal flags for sailing ships. Incorporated in 1847, Annin has made flags for the North Pole expeditions of Robert E. Peary, the North and South Pole flights of Robert E. Byrd, the Mount Everest expedition of the National Geographic Society, and the Apollo moon missions of the National Aeronautics and Space Administration. An Annin flag is on the surface of the moon.

This home at 220 Roseland Avenue formerly belonged to Louis Annin Ames and his wife. Their residence was adjacent to the first golf course in Essex Fells and took up several lots. It was fondly known to family members as "the House of Seven Gables."

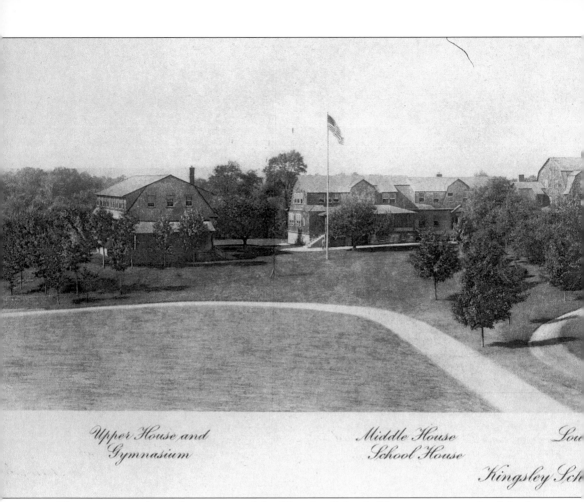

Upper House and
Gymnasium

Middle House
School House

Lou

Kingsley Sch

This panorama shows the campus of the Kingsley School. The preparatory school for boys opened in 1900 as a private day and boarding school. James R. Campbell, who helped to found the school, became the first headmaster and served for 28 years. Prior to building the Oak Lane campus, the school conducted some of its classes in the house located at the northwestern corner of Roseland Avenue and Wootton Roads. During its first year, the school had more

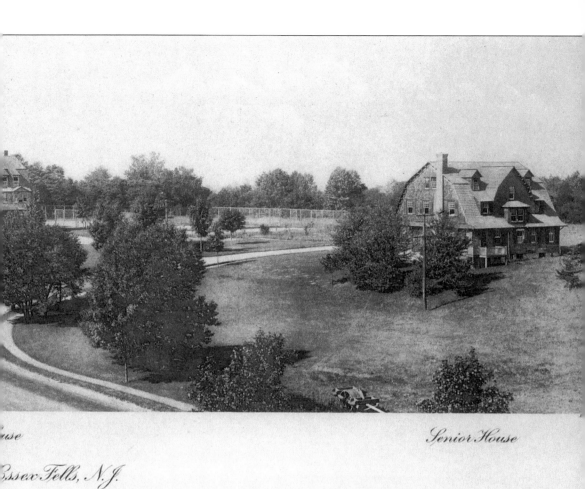

use

Senior House

Essex Fells, N.J.

teachers than students—five of the former and four of the latter. Kingsley existed for 41 years and closed in 1940. The campus was subsequently used by the Montrose School for Girls of Montrose, Pennsylvania, and later by the Northeastern Bible College. In 1945, the army used the school as a training ground for military cadets.

The front page of the June 8, 1934 issue of *The Kingsley Chronicle* stated that the school was named for Charles Kingsley, the English author, philosopher, and divine. James R. Campbell, Kingsley School headmaster, was personally acquainted with Charles Kingsley and held him in high regard.

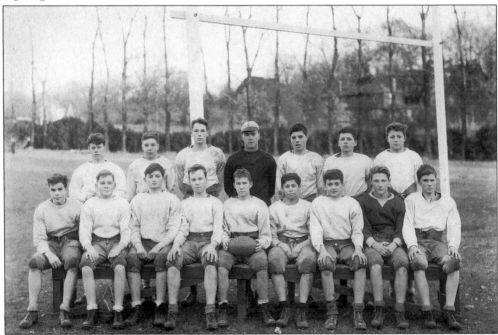

This picture shows some of the athletes at Kingsley School. In 1923, Kingsley had an enrollment of approximately 80 students. During that same year, 129 students were enrolled in the public school in Essex Fells. Kingsley students excelled in many sports, and the school teams often had excellent records.

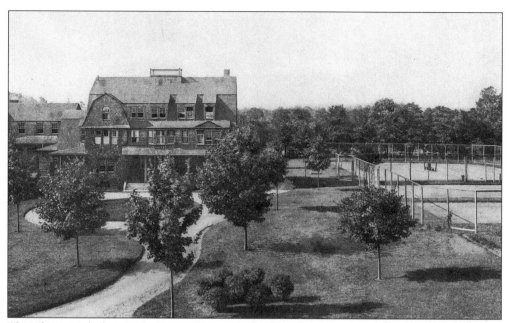

This photograph depicts the Lower House on the Kingsley School campus. Note the courts on the right, which are still used today. The borough purchased the tract for preservation and recreation after a medical conglomerate sought to overbuild the land.

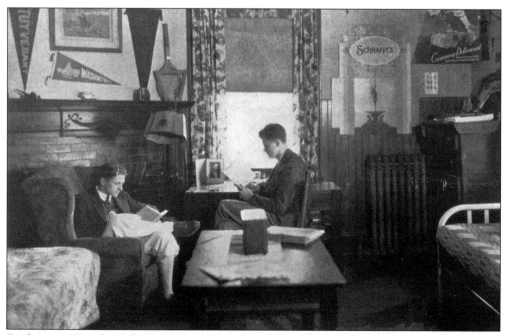

Students at Kingsley School came from all over the world. These students, from left to right, Duane Faralla and Thomas Seidel, received an award for their dormitory room. According to the Kingsley catalog, the residences were "unusually homelike and the bedrooms all well lighted, heated, and ventilated."

This photograph shows the George Ryerson house in Wayne, New Jersey. This house stood across the pike from the Abraham Ryerson house and was built in 1784. It was for a time the third oldest house in Wayne. To the left of the house is the tower of the Voice of America. In 1936 this house was disassembled and moved to Essex Fells. (Richard K. Cacioppo.)

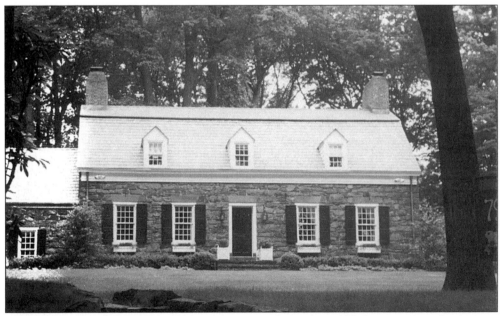

Pictured here is the George Ryerson house with its beautiful brownstone after it was reassembled and placed at 79 Hathaway Lane. Thus, one of the oldest homes in Essex Fells was really built in Wayne.

This photograph shows the Kingsley School's main lecture room, which also served as a social room.

This photograph shows the main dining room at the Kingsley School. Two Kingsley masters, Hoehn and Streeter, were the founders and directors of Camp Kingsley, located on Crescent Lake, 26 miles north of Portland, Maine. Half of the counselors at Camp Kingsley were teachers of secondary school.

This photograph was often featured in the Kingsley School catalog to illustrate that the school was in an area of natural beauty. The caption reads, "The hemlocks near Kingsley."

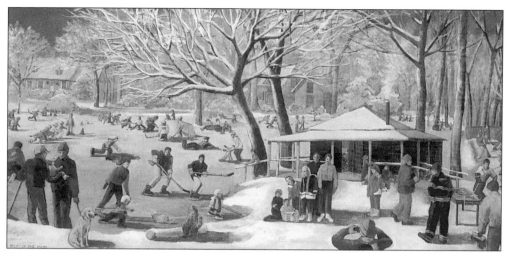

"The Spirit of the Pond," is the name of this painting by Essex Fells artist Caroline Medina. Caroline, as well as her parents, Stephen L. Bartholomew and Laura Miles Bartholomew, grew up there. Her remembrances of her father and his brothers and their neighbors, the Bate boys and Condit Moore, skating on the pond are captured in the painting. It was Condit's dad, Don Moore, who gave the pond to Essex Fells. The painting provides a mixture of old and new images—skating races and hockey playing—and brings to life the memories of this gifted artist and lifelong resident. (Courtesy of Caroline Medina.)

Shown above is the Toboggan Run. Although its exact location is unknown, it appears that it may have been located off of Fells Road near where the Essex Fells Skating Pond (formerly known as Willie's or Williamson's Pond) is located today. Maintaining the pond from 1941 to 1970 was Albert (Abbie) Leitch, whose tenure saw the addition of a hockey rink, floodlights, and improvements to the skating shelter, which was originally a chicken coop. Leitch taught everybody skating techniques, as well as hockey, and he kept a detailed record of all "ice" days on calendars. (Newark Public Library.)

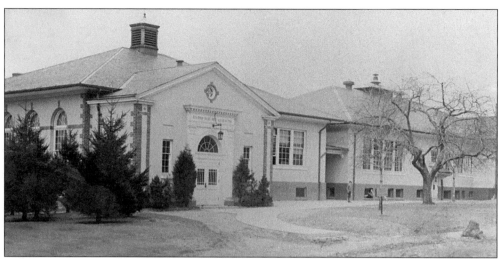

The Essex Fells Grammar School on Hawthorne Road opened in November of 1917. The school originally conducted classes in 1904 at a home located at 7 Buttonwood Road. The school's motto is seen above the door: "Studies pass into character." The grammar school housed kindergarten through eighth grade until the regional school opened in 1961. After that, it went through sixth grade.

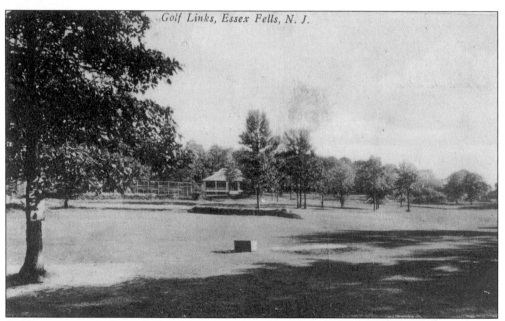

Golf got its start in Essex Fells in 1896, and this was the first golf course in the borough. The first course was basically a farm field. A more formal nine-hole course was designed by Alex Findlay, one of the preeminent golf course designers of the day. It was situated between the junction of Rensselaer Road and Roseland Avenue and the end of the playground by the school.

This photograph shows the Calvary Evangelical Free Church. Although relatively new to Essex Fells, the roots of the church go back to the early 1900s when it was comprised of a group of Norwegians in Orange and known as the Norwegian Evangelical Free Church. Services were conducted in Norwegian until the mid-1950s. With an increasing church membership, land was purchased in Essex Fells in 1957 and the church was completed in 1960. (Caldwell Library Local Historical Collection.)

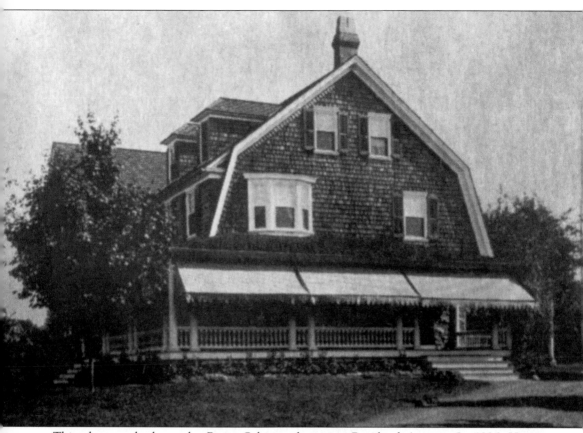

This photograph shows the Bower-Sylvester home on Roseland Avenue. In 1926, Horace Sylvester, the vice president of a New York bank, had a sick son named Johnny. As a possible stimulus for improving Johnny's health, Sylvester contacted the New York Yankees. Johnny's plight came to the attention of none other than George Herman (Babe) Ruth. Ruth dedicated homeruns to Johnny during the world series with the St. Louis Cardinals. On October 11, 1926, after the Cardinals had won the series, Ruth drove from New York City to the Sylvester residence, surprised Johnny, and presented him with autographed baseballs. Johnny was thrilled; his health got better; and after his 15 minutes of fame, he vowed to establish a baseball museum in his Roseland Avenue home. The story of Babe Ruth and Johnny Sylvester continues to be ranked as one of the greatest stories in the history of sports. (Caldwell Library Local Historical Collection.)

COMING OF BAMBINO DIVIDES FELLS HISTORY

Residents Already Speak of Events as Before or After Visit to Sick Laddie.

Johnny Sylvester, who played the role of "host" to the mighty Babe Ruth yesterday in the sickbed at his home in Essex Fells, was still improving from his illness today, while school children of the community were furious over having missed the opportunity of seeing the King of Swat.

The visit of the baseball idol to the 11-year-old boy was so unexpected, so swift and so lacking of ceremony that hardly a person in Essex Fells knew about it until it was over, and Johnny himself was so taken by surprise that he couldn't think of all the questions he wanted to ask the Babe until after he had left.

Johnny, who asked for a baseball autographed by the players in the world series when he was critically ill last week and who took a turn for the better when he was cheered by the receipt of two balls and a message from Ruth, was lying peacefully in bed yesterday, his two treasured baseballs on the coverlets of his bed.

Recognizes His Idol

A car drove up to the home of his father, Horace C. Sylvester, Jr., a vice president of the National City Company, in Roseland avenue and two men—one very large—and a woman got out and rang the Sylvester bell.

The maid answered the bell. She has a very poor memory for faces, and to her the Bimbo was just another man. The Babe asked if they might see Johnny. Well, she would have to ask the nurse.

Permission was granted and the three walked softly into Johnny's bedroom, where Mrs. Sylvester and Miss Oriell, the nurse, were at the bedside.

It was Johnny who recognized his idol.

"Why—it's Babe Ruth!" he cried, his eyes looking like saucers as he gasped and stared in wonderment.

"Hello, Johnny," said the Babe. The ballplayer said he hoped Johnny was feeling better but after that could think of nothing else to say. Neither could Johnny.

Holds Up Committee

After expressing his hopes for a speedy recovery once or twice more, the Babe remarked that there was the little matter of a ball game at Bradley Beach, in which he was scheduled to play.

After bidding adieu to Johnny and receiving the thanks of Mrs. Sylvester, Mr. Ruth took his leave.

He was sped to Bradley Beach, where a mayor's committee of welcome had been waiting for him for two hours.

Johnny sat up in bed today, but is not yet able to get up entirely. He is well on the road to recovery, however, and it is believed that it will be only a matter of time when he will be walking about.

And as a result of the Babe's visit, the history of Essex Fells promises to become divided in two parts—before the coming of Ruth, and after. It was forecast today that in years to come old-timers would speak about "the time when Babe Ruth came to see Johnny Sylvester."

'DR.' BABE RUTH CALLS ON HIS BOY PATIENT

The Home-Run King Keeps Reception Waiting While He Sees Lad His Homers Saved.

JOHNNY GAZES AND GULPS

His Idol Also Finds It Hard to Converse — "Gee, but I'm Lucky," Boy Gasps Later.

Special to The New York Times.

ESSEX FELLS, N. J., Oct. 11.—While the Mayor and the influential citizens of Bradley Beach waited impatiently two hours this afternoon for Babe Ruth to arrive for a reception in his honor, a small boy recovering from a severe illness in his home here con-

On October 12, 1926, the byline of Essex Fells made the first page of *The New York Times* in an article describing Babe Ruth's visit to the Sylvester home. A few weeks later in Philadelphia, when asked of Johnny's condition, Ruth is reported to have replied, "Who the hell is Johnny Sylvester?"

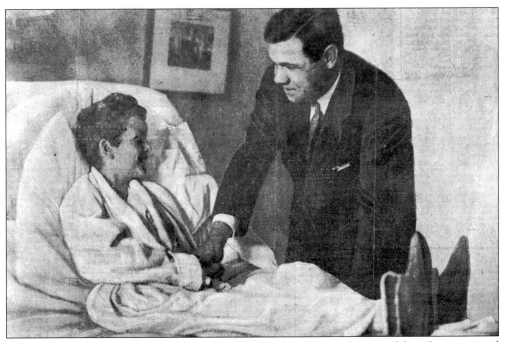

This photograph shows Babe Ruth greeting Johnny Sylvester at home. Although tongue-tied during most of the visit, Johnny gasped afterwards, "Ain't he big?" (The Babe Ruth Birthplace and Museum, Baltimore, Maryland.)

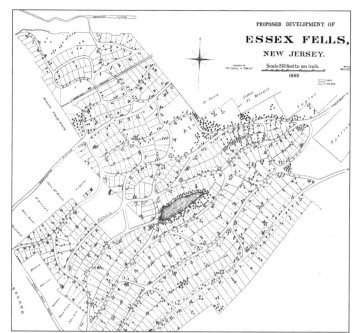

The first subdivision map of Essex Fells was dated 1899. On this map, Essex Fells extends right through to the intersection of Roseland and Eagle Rock Avenues, where the Roseland Post Office is located today. In subsequent years Essex Fells transferred a good portion of its land to Roseland, so that Fells Road became the boundary line with Roseland. The transfer was done about the time of the development of the Harrison Avenue School in Roseland. (Borough of Essex Fells.)

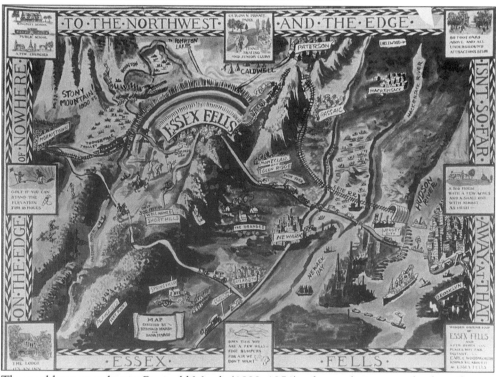

The world-renowned artist Reginald Marsh (1898–1954), whose relatives ran the forge factory in town, made this wistful map depicting Essex Fells. The Marsh family gave copies of this picture to many Essex Fells residents, who often displayed it prominently in their homes. Note that Marsh states that Short Hills is really well named, with its 300-foot elevations compared to the higher hills of Essex Fells, which approach 600 feet. (Newark Public Library Photo.)

Two

FAIRFIELD

The Dutch arrived in Fairfield in 1669 and purchased the land from the Native Americans. After traveling over the Great Notch Road, the Dutch decided to live on the bottomlands of the Passaic River, possibly because these lands reminded them of their native Holland. English settlers arrived in 1699. Fairfield, the oldest village in West Essex, was first known as Gansegat, Dutch for "duck's pond," then as Horseneck during the English predomination, and then as Caldwell Township, reflecting the Revolutionary fervor. Among the early settlers in Fairfield was Simon Van Ness, who owned a large tract of 300 acres, for which he obtained title through some early Native American deeds. Van Ness and several other Dutch settlers took part in the Horseneck riots. The land that was Fairfield was part of the Horseneck tract. The area was known as Caldwell Township and included most of what is now West Essex. What was likely the first church in West Essex was established in 1720 at the intersection of what is now Hollywood Avenue and Fairfield Road. In 1804, the Fairfield Dutch Reformed Church was built farther down Fairfield Road.

In 1798, Caldwell Township was created. It consisted of a large tract that eventually became nine separate towns. Today, Fairfield's ten square miles holds a community of about 8,000 residents. Its daytime population, which includes industrial and office employees, rises to nearly 30,000.

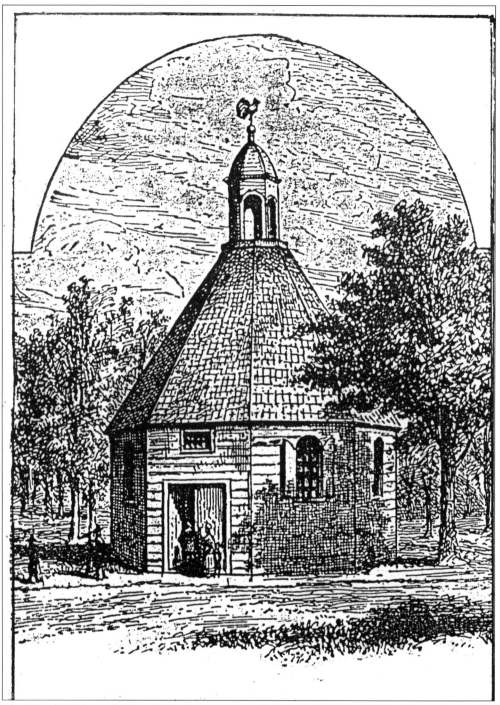

The Dutch Reformed Church Society was organized in Fairfield in 1720. The congregation worshipped in a square log church, until it was destroyed by fire in 1744. Then, this octagonal church was built of mud, stones, and logs on the same site. For the first 85 years of its existence, the church held services at this location, the current intersection of Fairfield Road and Hollywood Avenue. (Harold Peer.)

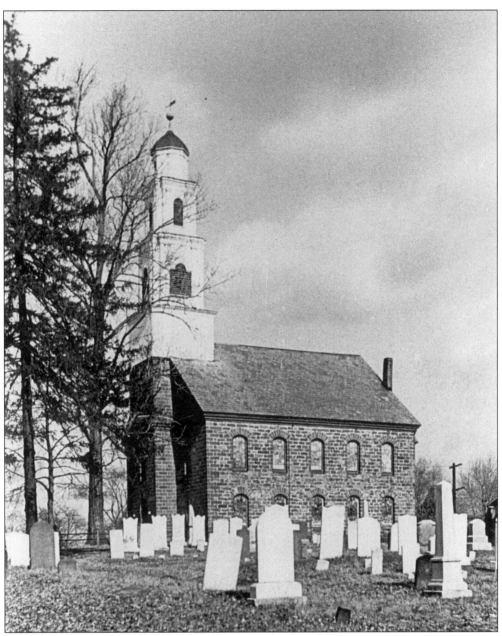

In 1804, the Dutch Reformed Church decided to erect a new brownstone edifice. The stone was a gift from the pastor, the Reverend John Duryea, who owned a quarry in Little Falls. Brownstone from this quarry also was used for the construction of Trinity Church in New York City. The Dutch Reformed Church is one of the finest examples of English Georgian–style Colonial architecture in New Jersey. The church houses a pulpit from which the word of God has been preached for more than 200 years. Until Civil War times, there were services in Dutch conducted at the church. For many years the Fairfield Dutch Reformed Church, from its prominent position on top of a knoll near the intersection of Fairfield Road and New Dutch Lane, was the center of religious worship and social activities in Fairfield. The building is listed in the National Register of Historic Places. (Newark Public Library.)

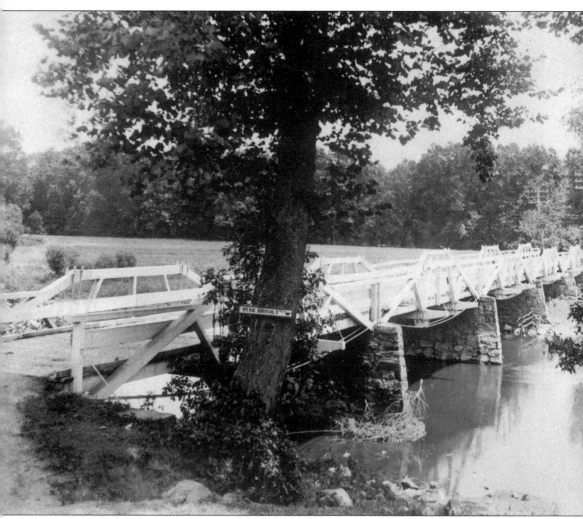

It is said that Native Americans used rope bridges to cross the Passaic and Pompton Rivers at Pine Brook, Horseneck, and Two Bridges. Then, in the 18th century, white settlers built wooden bridges. These bridges have been replaced by steel ones, which are not as magnificent as the wooden ones. During the era of the wooden bridges, signs that read "Walk your horses" were posted at the end of all bridges in an attempt to control vibration. This photograph shows the Horseneck Bridge as it appeared in the early 1900s. (Caldwell Library Local Historical Collection.)

This scene along the Passaic River dates from the late 1800s. The Passaic, with headwaters in Mendham, winds in a serpentine way for 90 miles, passing through 7 counties and 45 municipalities before emptying into Newark Bay. The river's fertile valley in Fairfield was just right for the early Dutch settlers.

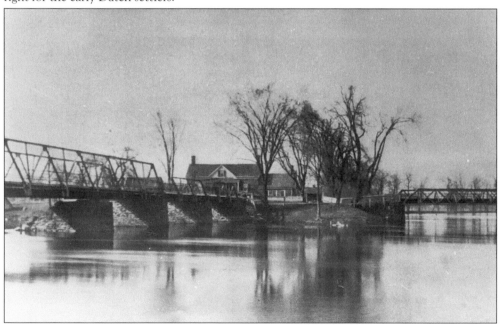

This photograph, c. 1915, shows Two Bridges. The building on the other side was the old Dey House, later known as the Two Bridges Inn, which burned in 1963. The road over Two Bridges was one of the important military routes during the Revolutionary War as it lay between the Hudson highlands and Morristown. It is said that, en route to New York, George Washington stopped here and had lunch on the front lawn under the beautiful shade trees. (Caldwell Library Local Historical Collection.)

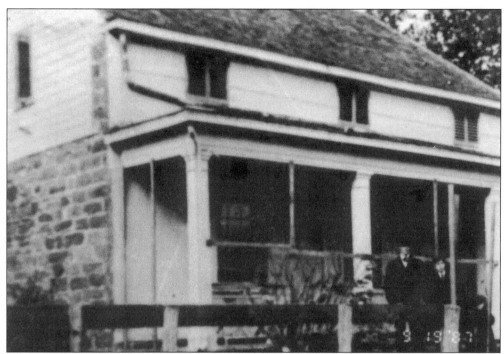

This 1896 photograph is the oldest known photograph of the Van Ness House. Built by a member of the Van Ness family, the house dates back to pre-Revolutionary War times. Simon Van Ness purchased 300 acres in the area in 1701. His son Isaac settled in Fairfield, and his son Peter probably built the home in 1724. (Harold Peer.)

Located at 1237 Bloomfield Avenue in Fairfield is this building, *c.* 1802. As the Bell Hotel, it was a stagecoach stopover. Later, it became the Kit Kat Club and then the White House Furniture store. The current owner is looking for a new tenant to continue the building's almost 200 years of use in West Essex.

This photograph shows the Peter Van Ness house, located at Little Falls Road and Dey Avenue. Title to the land on which the house stands was given to Simon Van Ness in 1701. The original, unassuming brownstone structure consisting of one room and a loft has been altered over the years by various additions. In the 1930s, the building served as the Orchard Club Restaurant.

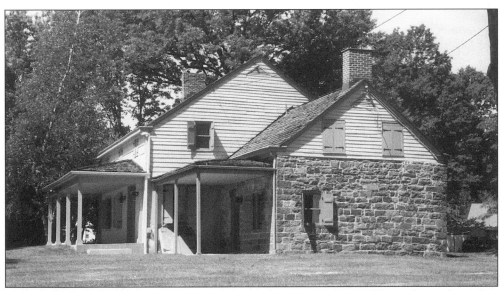

This photograph shows the oldest part of the Peter Van Ness house. The earliest reference to the house is November 17, 1724, when it was used as a terminal point in delineating the Great Notch Road, now known as Little Falls Road. The Van Ness homestead is an architectural creation of the brownstone era of the 18th century. Dutch settlers cut the sandstone by hand from the banks of the Passaic River and then hauled it by oxen to their building sites. In 1975, the Van Ness Homestead was listed in the National Register of Historic Places.

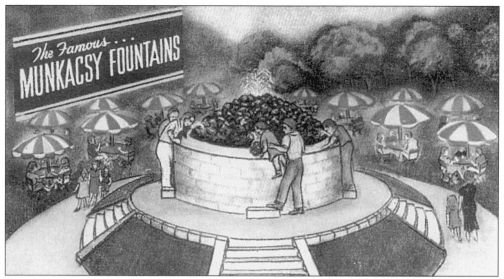

In January of 1938, John Munkacsy, a Hungarian immigrant who had a picnic grove and beer garden near the Passaic River on Camp Lane, paid $306 to have a well drilled for the upcoming summer season. When he tasted the water, he spat it out and said, "Phooey, $300 shot to hell." Soon Munkacsy had the water tested by the State Department of Health and the testing revealed that the water was very hard due to an unusually high amount of calcium and magnesium sulphates. Soon the water became the talk of the country and thousands came to purchase it and swore to its curative medicinal benefits. Testimonials poured in on how the water cured rheumatism, arthritis, neuritis, and other ailments. Some said they threw away their crutches after drinking it. John Munkacsy sold thousands of gallons from his picnic gardens and from a storefront on Route 6. (Harold Peer and George Rosewall.)

Munkacsy even became the sponsor of a radio show. In time he sold the rights to distribute the water to a Dr. Arnold T. Goldwater, a dentist on the staff of New York's Sing Sing Prison and the brother of New York City's Commissioner of Hospitals, who tried to get gold from the water. Goldwater collaborated with Samuel J. Burger, banquet manager of New York City's Cotton Club and a theatrical promoter who once tried to get the Hauptman jury on a vaudeville tour. Apparently the water wasn't the miracle cure that many first claimed, and it became a thing of the past. In the picture above, author Charles Poekel is seen after discovering the old Munkacsy well with Harold Peer in an overgrown area off Camp Lane. (Harold Peer.)

48

This photograph shows Johnny Lebeda, age four, sitting on the steps of the "summer kitchen" of his great-grandmother's farm, located on Sand Road in Fairfield. Involved in farming for over 100 years, the Lebeda family used the summer kitchen as housing for hired hands and as a receiving depot for the harvested crops of fruits and vegetables. The summer kitchen predates the Civil War. It was formerly part of the DeBaun farmstead. (Courtesy of the Lebeda family.)

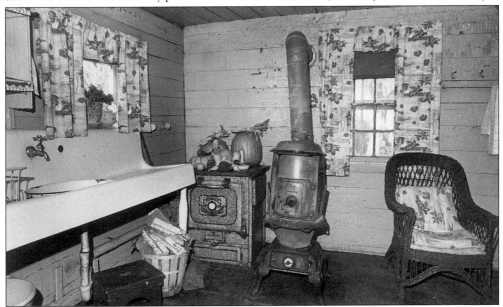

This photograph shows the interior of the Lebeda's summer kitchen. Note the two 19th-century stoves in the corner: a stove for cooking and an early Sears Roebuck potbellied, wood-burning stove for heating the building. The main crop of the Lebeda farm was horseradish, which was sold to a market in Newark. The Lebedas also sold their fruits and vegetables to New York markets. (Mary Lebeda.)

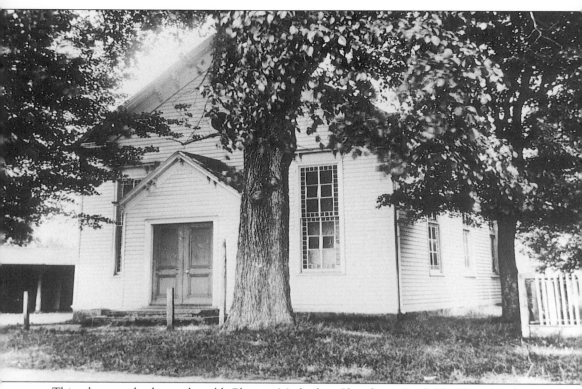

This photograph shows the old Clinton Methodist Church in Fairfield. This church was organized by six men and perhaps 20 women in 1823, and this building was completed the same year. Before then, most of the Fairfield residents attended the Fairfield Dutch Reformed Church. A Methodist circuit rider brought about a revival, which resulted in new Methodist churches in the Clinton area of Fairfield and in Pinebrook. For many years both churches were served by one pastor.

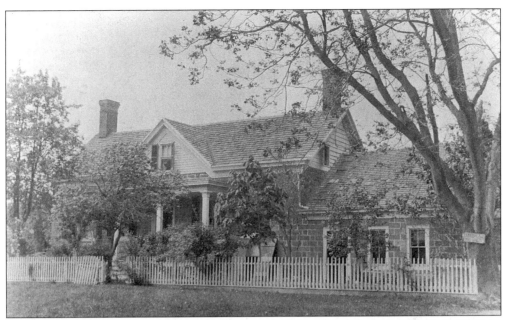

The Post family home, located near Two Bridges and the Passaic River, was built in 1779 by Thomas Dey. Dey owned a nearby tannery, a fur hattery, and a store. The stone lintels and the very carefully cut and finished stones on the front wall of both units—in contrast to the irregular stonework of the sides and rear walls—were typical of this period. (The New Jersey Historical Society.)

This 19th-century photograph shows a member of the Post family in front of the family homestead located near Two Bridges. Thomas Dey's daughter married Cornelius Post and later married a Mr. Hughes. Her only son, Dirck Dey Post, born May 6, 1791, was the father of C. Henry Post, who was born in the house in 1820 and who owned it until 1900. The house passed to Henry's son, Abram Post, whose widow sold it to the McGlinns. Once owned by the Twin Rivers Club, the house later burned down. (The New Jersey Historical Society.)

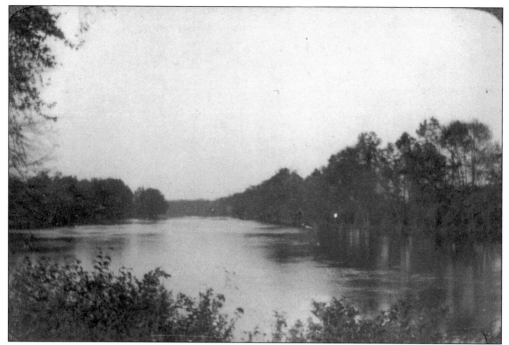

This photograph shows the Passaic River and its banks as they appeared in the late 1800s. Although the Native American presence in this entire area goes back to at least 5000 B.C., the Leni Lenape of the Algonquin tribe were here when the first white visitors arrived. These original dwellers roamed and lived along the entire course of the Passaic River. They hunted in the forests, fished in the river and its tributaries, raised crops, and occasionally fought their enemies, the Iroquois.

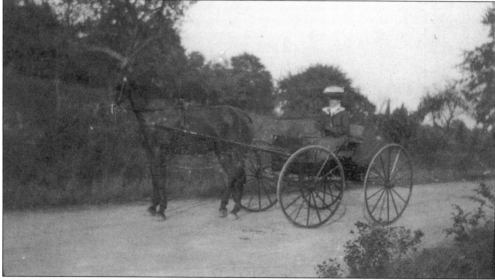

This photograph shows a horse and buggy taking advantage of the fine scenery of the Passaic River Valley. In this valley Hartman Vreeland, one of the first settlers, found a huge deposit of red sandstone on his property and developed it into a quarry. That quarry provided building material for many of the houses in the area.

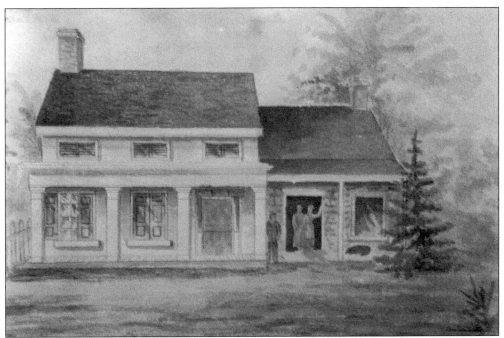

This painting of the Van Ness house was by Sarah Doremus, wife of Thomas Peer. The Doremus family were among the early settlers and they were part of a branch of the Pompton Plains family of the same name. (Harold Peer.)

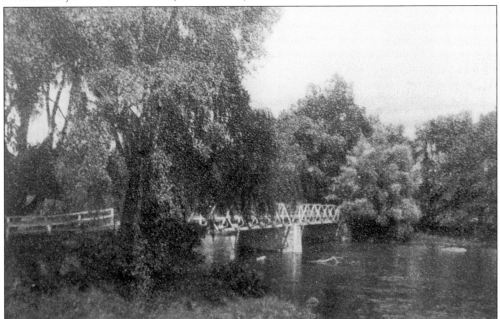

This early-1900s postcard illustrates the beauty of one of the wooden bridges at Two Bridges, located at the juncture of the Pompton and Passaic Rivers. The Derrick Dey Tavern, which was located at Two Bridges, served during the Revolutionary War as the 1780 headquarters of Col. Charles Stewart, the army's commissary general. The army's post office was also located at Two Bridges.

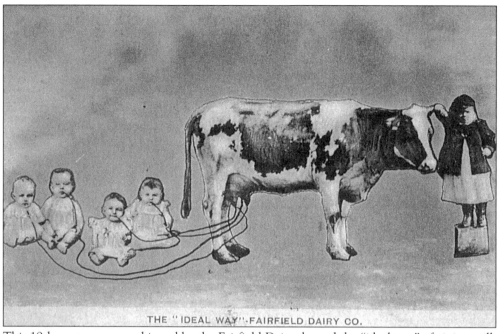

This 19th-century postcard issued by the Fairfield Dairy showed the "ideal way" of giving milk to babies. No doubt the humor was an utter delight to those who received the postcard. (John C. Collins Collection.)

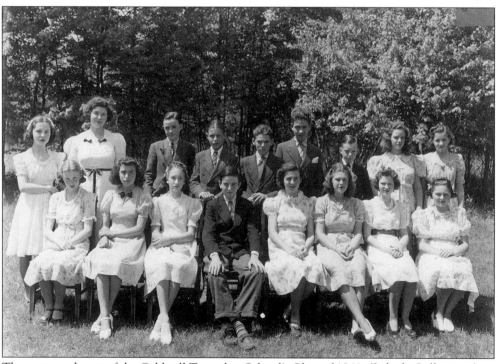

These are graduates of the Caldwell Township School's Class of 1941. (Lebeda Collection.)

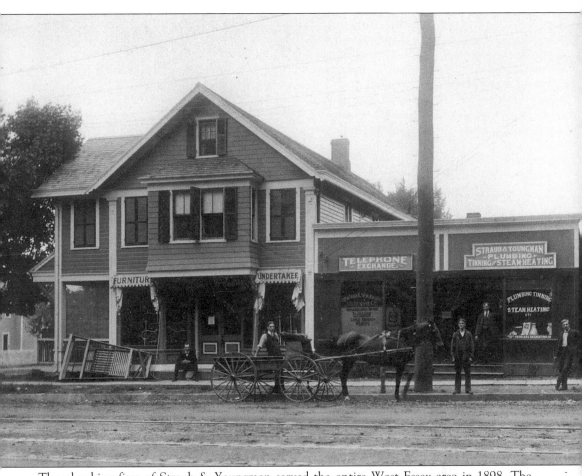

The plumbing firm of Straub & Youngman served the entire West Essex area in 1898. The business was located on Bloomfield Avenue in Caldwell, near where the American Legion Hall is today. Eugene Straub still carries on the family tradition, making this the longest continuous business operating in the West Essex area. Bloomfield Avenue was formerly called the Big Road. (Straub Collection.)

Thomas Peer Ness is seen with two of his dogs in front of the Van Ness house, which he purchased in 1896. He became the magistrate of Fairfield during the 1920s and 1930s. At times his son Edward R. Peer served as the recorder, the position known today as court reporter. (Harold Peer.)

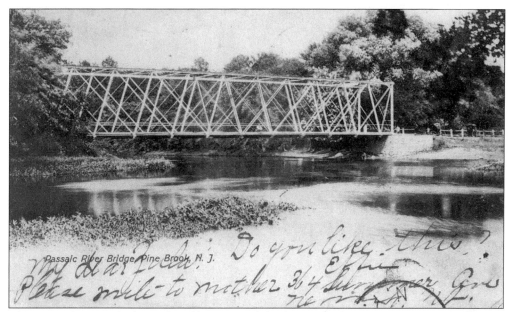

Passaic River Bridge, Pine Brook, N. J.

This 1896 photograph shows the old Pine Brook bridge across the Passaic River on Bloomfield Avenue, between Fairfield and Pine Brook. In the 1900s, all of the bridges across the Passaic were wooden and all possessed magnificent charm. The first bridge at this site was erected in the mid-1700s. Ores from the Morris County mines were often brought over this bridge en route to the smelting furnaces in Newark. The bridge became more popular than the Swinefield Bridge in Roseland. During the Revolutionary War, this bridge was used by Tories and irregulars on their way to the countryside to hide their animals. (Straub Collection.)

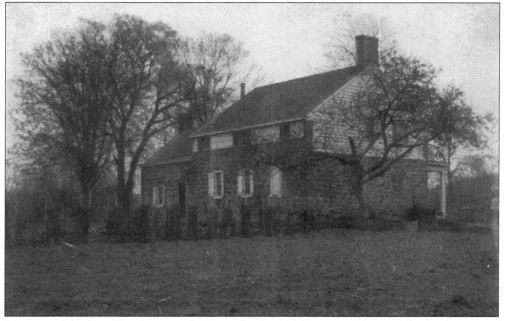

The rear of the Van Ness house is shown in this late-19th-century photograph. At the time of the purchase by Thomas Peer, the property had 88 acres. Hunting for arrowheads of the Leni Lenape was a favorite pastime in this area. (Courtesy Harold Peer.)

This photograph shows the Lebeda truck farm in the 1940s with James Lebeda at the reins. The Lebeda family came from Long Island and they have been involved in farming in Fairfield for almost 100 years. (Lebeda Collection.)

Shown in this photograph are some of the vegetables from the Lebeda truck farm. (Lebeda Collection.)

Taking a break on his bicycle is young Edward R. Peer. The son of Thomas Peer, he later became the father of Harold Peer. (Harold Peer.)

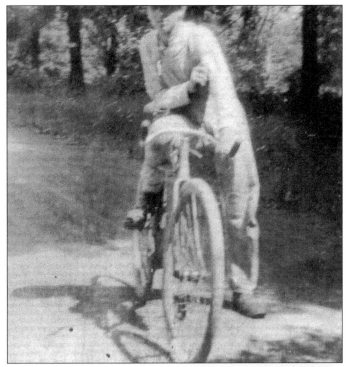

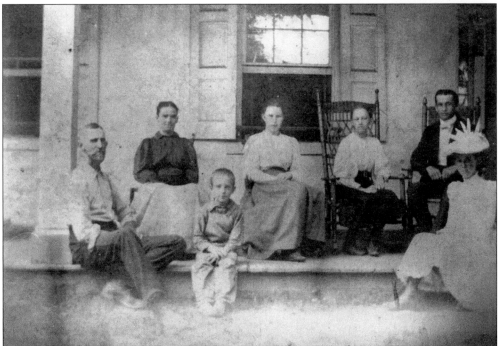

Seen on the front steps of the Van Ness house are, from left to right, Thomas Peer, his wife, Sara Doremus Peer, Edward R. Peer, two cousins, and two unidentified schoolteachers. It is likely that the schoolteachers were interviewing Edward and his parents before acceptance in school, a normal procedure in those days. (Harold Peer.)

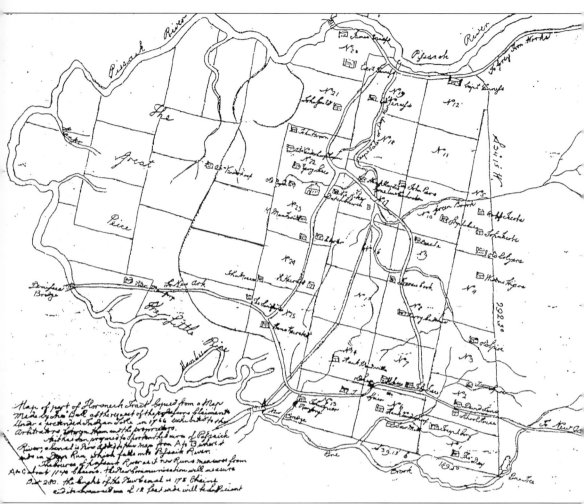

1776 Map of Fairfield Thomas Milledge Father's Map (with original notation): "Map of Part of Horseneck track copies from a map made by his dad at the request of the proprietor's claimant under a pretended Indian Lake in 1766 exhibited to the arbitrators between them and the proprietors.

As it has been proposed to hook the course of Passaic River, a canal is now added to this map from A to B where it runs in deep run which falls into Passaic River

The course of Passaic River as it now runs measures from A to C about 1140 chains. The new communication will measure about 280. The height of new canal is 17.5 chains and its supposed of 12 fee wide will be sufficient." (Harold Peer.)

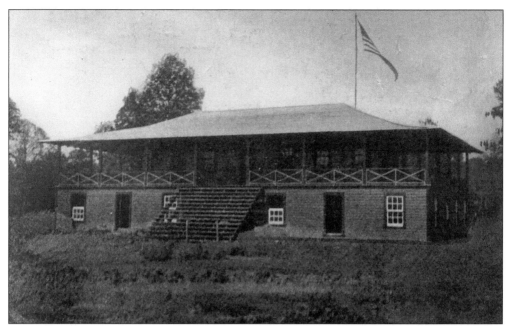

World War I started on June 28, 1914, with the assassination of the heir to the Austrian throne, thousands of miles away from the small farming community of Fairfield, New Jersey. The United States declared war on April 6, 1917, and the United States Navy established military barracks and a rifle range on Horseneck Road the following year. This rare photograph shows the administration building of the naval military compound. Originally, tents were pitched to house the sailors. Later, the sailors built barracks and buildings. According to reports, extra ammunition was fired off in celebration at the Fairfield range after news arrived of the final surrender. (Harold Peer.)

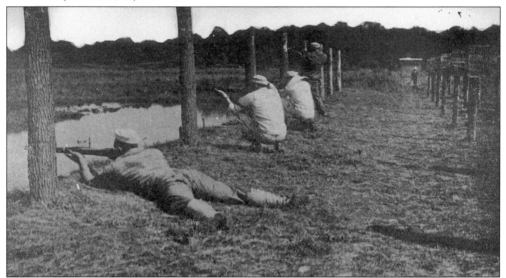

This photography, *c.* 1918, shows U.S. Navy sailors taking aim at targets on the 200-yard firing line in Fairfield. The sailors came to Fairfield from the Brooklyn Navy Yard for one week of training in small arms. The weapons they fired included 30/30s, .50-caliber handguns, machine guns, and one-pound canons. (Harold Peer.)

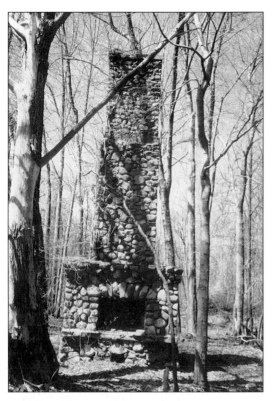

This chimney is a present-day reminder of the military presence in Fairfield in 1918. It was part of the main administration building at the military compound. It is interesting to know that there was no electrical service at the military site and all lighting was done by lanterns. Electricity did not come into use in this area until 1932. (Harold Peer.)

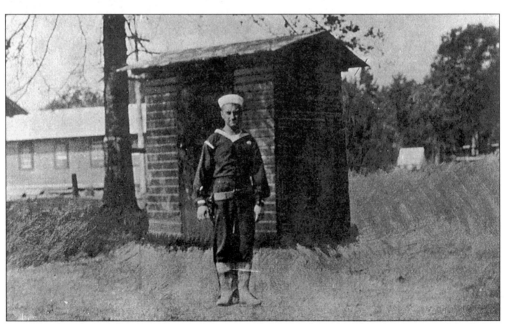

Seen in the above photograph is a sentry standing guard at the "brig." Along with officers' quarters and a pavilion for recreation, this completed the makeup of the naval presence in Fairfield during World War I along the banks of the Passaic River. (Harold Peer.)

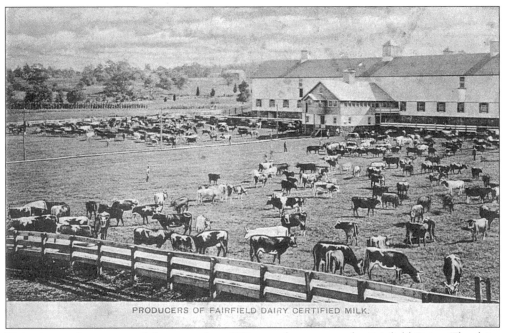

PRODUCERS OF FAIRFIELD DAIRY CERTIFIED MILK.

This picture shows some of the more than 800 cows that were at the Fairfield Dairy. The dairy was located on Passaic Avenue, at the present-day site of Caldwell Airport.

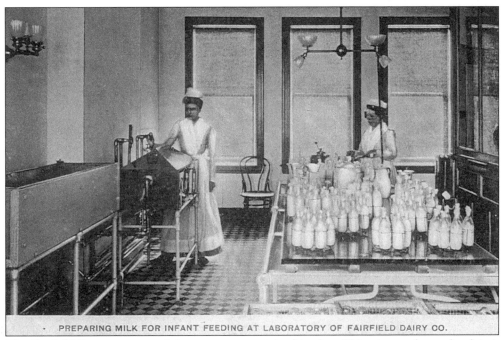

PREPARING MILK FOR INFANT FEEDING AT LABORATORY OF FAIRFIELD DAIRY CO.

The Fairfield Dairy was one of the most innovative of its day. This picture shows the dairy's laboratory, which was located at its Montclair depot. There, technicians in white coats mixed individual formulas custom-tailored for each baby. It was speculated that skim milk and water were the secret ingredients used to concoct the right formulas. (John J. Collins.)

This is a rare late-19th-century photograph of the bottling house of the Fairfield Dairy. The bottling plant was built in 1890. Heavy cables carried the milk from the stables to the bottling plant and in minutes the newly drawn milk was cold. The dairy was owned by Stephen "Dutch" Francisco, who has been described as a small man with a goatee who always wore a swallow-tailed coat. A road leading to Dutch's house was named Dutch Lane, and when the house was moved it became New Dutch Lane, which exists today. (Collins Collection.)

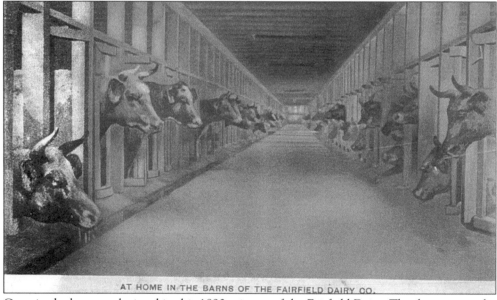

AT HOME IN THE BARNS OF THE FAIRFIELD DAIRY CO.

Cows in the barn are depicted in this 1890s picture of the Fairfield Dairy. The dairy was at the peak of success from 1890 to 1924. According to Fairfield author Roscoe DeBaun, the dairy met its demise after a tuberculin scare and never recovered. The land from the dairy was sold to make way for Caldwell airport. (Collins Collection.)

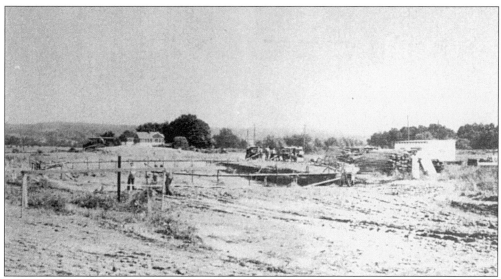

The above photograph, taken on July 16, 1940, shows the land formerly of the Fairfield Dairy upon which the Curtiss-Wright Corporation received a contract to build an aircraft production plant. This photograph shows the scene just four days after the contract for construction was received. In four days of time, engineers and crews staked out building lines, established grade levels, stripped top soil and stored some, excavated for foundations, and laid well points and piping. (Curtiss-Wright Corporation.)

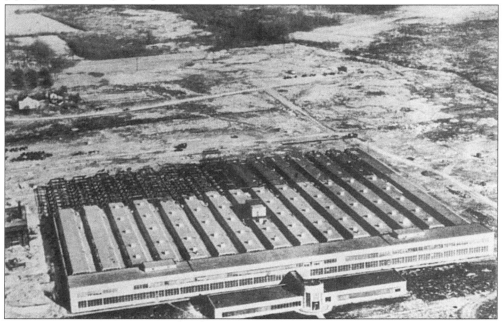

During the next 38 days, concrete footings, piers, and walls were laid. A floor of concrete was started along with the commencement of the roofing work. The above picture, taken just 68 days later, shows the main plant where production is underway, as well as a 200-foot rear extension in process of construction. Thus, in a period of only 68 days, the Curtiss-Wright Corporation went from groundbreaking to aircraft production in what was then called Caldwell Township and now Fairfield! (Curtiss-Wright Corporation.)

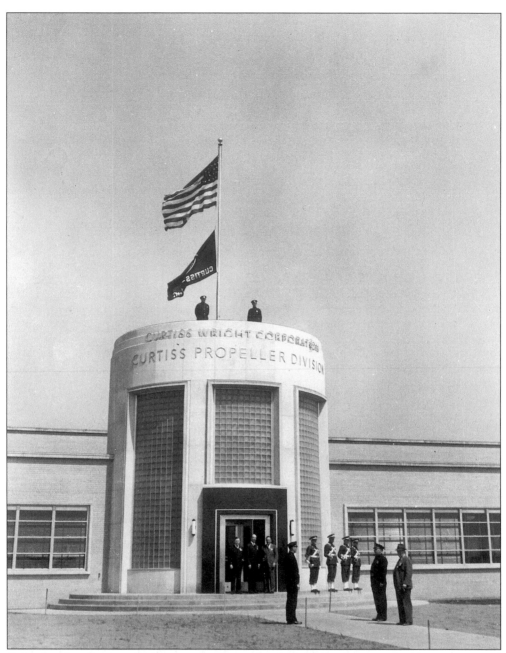

Seen above are the opening day ceremonies on April 19, 1941, of the main administration and production building of the Propeller Division of Curtiss-Wright Corporation. The Curtiss-Wright Corporation manufactured airplanes, engines, and propellers and came into existence in 1929 when two of the pioneer aircraft companies merged, those of Glenn H. Curtiss and Wilbur and Orville Wright. Propellers from the Fairfield facility would greatly contribute to the war effort. Prior to the United States entry into World War II, Curtiss-Wright produced the P-40 aircraft for France. Employees from the Curtiss-Wright corporation lived throughout West Essex during the World War II years. (Curtiss-Wright Collection.)

SPECIAL $5.⁰⁰ OFFER

TRIAL INTRODUCTORY LESSON

At a thousand feet you are given complete control of the ship and it's yours until it's time to land.

Try it and experience a real thrill, find out what it's like to be at the controls.

WHITE FLYING SERVICE, Inc.

(SCHOOL DIVISION) - J. T. McCoy, Rep.

ESSEX AIRPORT - <u>Caldwell, New Jersey</u>

THIS IS YOUR LOG.

To be filled at completion of flight.

Name————————

Address————————

Date————————

Type of Aircraft————

License No.————————

Type of Engine————

Time————————

Attested by————————

WHITE FLYING SERVICE, Inc.
(School Division)

J. T. McCoy, Rep.

ESSEX AIRPORT

Caldwell New Jersey

With this special coupon, a person could learn how to fly an airplane at Caldwell Airport. The airport has been known by various names over the years: Marvin Airport, Essex Airport, Curtiss Essex Airport, Caldwell Wright Airport, West Essex Airport, and Caldwell Airport. (Straub Collection.)

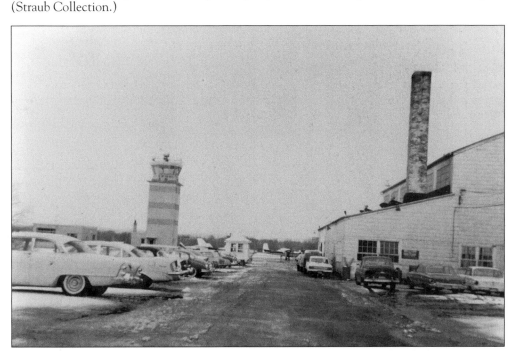

This photograph shows the control tower and the main hangar at Caldwell Airport. At one time the airport was considered as a possible additional hub for Newark Airport. It was from this airport that John F. Kennedy Jr., his wife, Carolyn, and his sister-in-law Lauren G. Bessette took off on July 16, 1999, in a small Piper Saratoga single engine airplane which later crashed into the ocean on its approach to Martha's Vineyard, killing all onboard. (New Jersey Historical Society.)

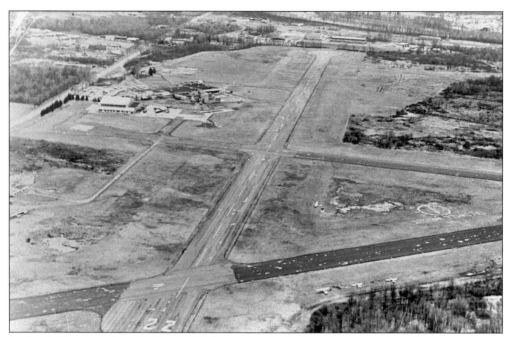

In the 1940s, this is how Caldwell Wright Airport looked on the approach to the main runway. During World War II, more than 100,000 airplane propellers were manufactured at the Propeller Division of Curtiss-Wright, which was adjacent to the airport.

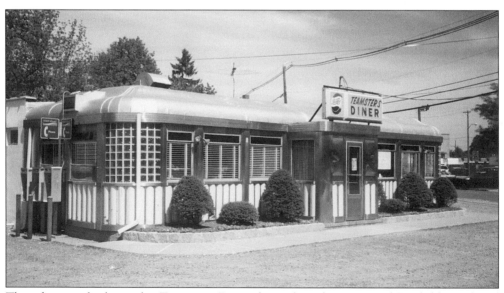

This photograph shows the Teamsters Diner, located at the corner of Fairfield Road and Hollywood Avenue. The diner was used in the filming of many movies, including Angel Heart. New Jersey has the reputation of being the diner capital of the country. Of some 6,000 diners nationwide, more than 2,000 are in New Jersey.

Three

NORTH CALDWELL

Although North Caldwell has one of the smallest populations of the West Essex towns, it was one of the earliest areas to be settled. Situated on some of the highest land in the area, its forests of oak and hickory were an attraction to the early pioneers. It is bounded by Caldwell on the south, Cedar Grove on the east, Fairfield on the west, and Passaic County on the north. Fifty years before the Revolution, the area was sparsely populated. After the forests were depleted, farmers settled in the area. Hendrick Kollier, or Collier, had a large tract of land, as did Aaron Simons, John Tindall, Henrik Steeger, Jonathan Beach, Thomas Sandford, Stephen Gould, Ezariah Crane, Joseph Baldwin, Jacob Jacobus, John Noe, David Harrison Jr., John Mead, Evert Van Zile, and Van Riper. Hendrik Bush held title to a part of the area that was known for many years as Bushtown. Mountain Avenue was referred to "Aunt Naomi's Lane," apparently after local resident Naomi Baldwin.

The area of North Caldwell attracted many people during the summer, and at one time there were numerous boardinghouses and country lanes. Today, there are only three remaining homes from the 18th century: the Francisco, Bach, and Sandford-Stager homes.

Industry in North Caldwell was centered around the Old Green Brook, where bark mills, gristmills, and sawmills were operated by Peter and Thomas Speer, Thomas Sindle and his progeny, the Sanderson family, and others. Fred and Frank H. Baldwin maintained an icehouse and later started a butcher route.

Farming, long a tradition, continues to this day with the Matarazzo farm located along Mountain Avenue.

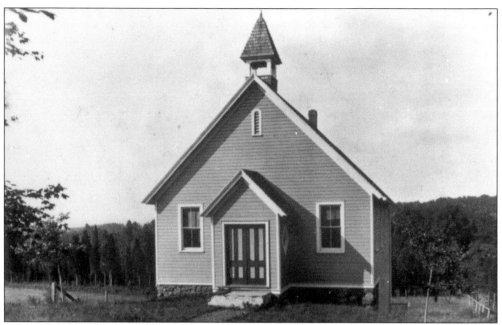

The Borough of North Caldwell was incorporated in 1898, after having been a part of Caldwell Township for 100 years. Citizens sought independence in order to improve the roads and the schools. Toward the end of the independence movement, the North Caldwell Borough Improvement Association was formed and the small meeting hall pictured here was built on Gould Avenue. The association was the most influential factor in civic actions. In the association's meeting hall, church services were held, as well as suppers, socials, and other events. The building was later moved to Mountain Avenue and became part of the Alliance Chapel. (North Caldwell Historical Society.)

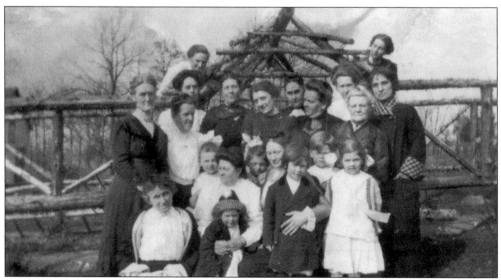

This photograph, c. 1910, shows members of the Ladies Auxiliary of the North Caldwell Borough Improvement Association. This group took responsibility for the care of a new library, which contained 300 books. (North Caldwell Historical Society.)

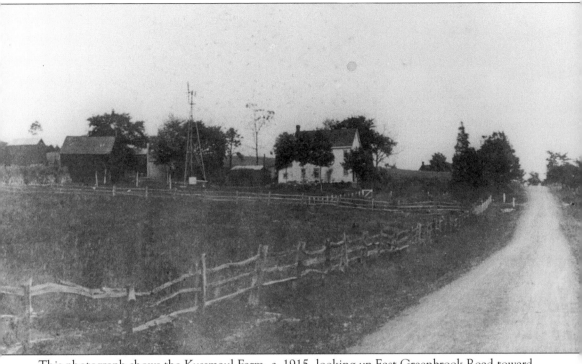

This photograph shows the Kussmaul Farm, *c.* 1915, looking up East Greenbrook Road toward Mountain Avenue. The farm is on the left. Louis F. Kussmaul was a Civil War soldier who returned from the war to live on his farm. He was elected one of the first councilmen in North Caldwell on March 31, 1898. John Kussmaul, the last person to live in the house, gave this photograph to Charles Komer and his wife of Moultonboro, New Hampshire, who, in turn, presented it to North Caldwell historians. In the 1950s, the Komers built a house in the pasture surrounded by the split rail fence. The chimney and roof to the right of the house at the top of the hill is the Stager house, built *c.* 1777. The Kussmaul house and buildings were burned in a practice fire conducted by the North Caldwell Fire Department. The house at 17 East Greenbrook Road now occupies the site of the old home. (North Caldwell Historical Society.)

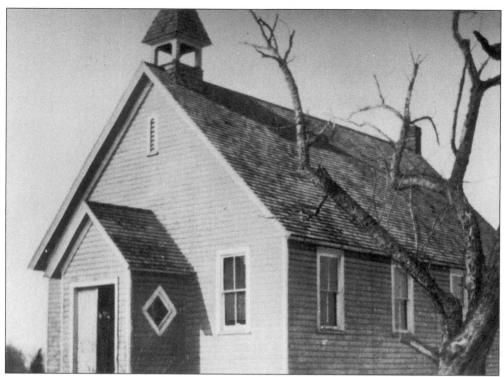

This photograph shows the original one-room schoolhouse on Gould Avenue in North Caldwell. Such schools were located in each of the West Essex towns.

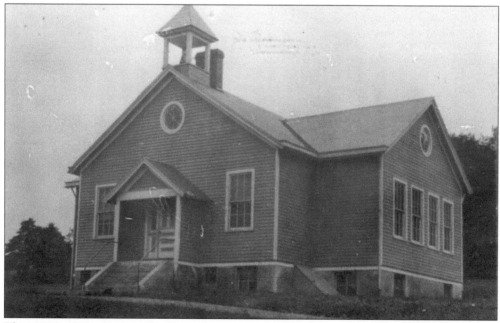

This 1910–1911 photograph shows the two-room schoolhouse located on Gould Avenue, erected c. 1900. Until the Grandview Avenue School was built, all of the borough's elementary schools were located on Gould Avenue. (North Caldwell Historical Society.)

During the late 1800s and early 1900s, North Caldwell was a popular resort because of its mountain air. Several lodges and boardinghouses were located here. This group of visitors, bound for the Osego Lodge on Grandview Avenue, was picked up at the train station. Many 19th-century suburbs started as summer resorts. (North Caldwell Historical Society.)

Taking a bike ride from the Sandford-Stager homestead, c. 1900, are the five daughters of Marcus and Maria Stager, Retta, Hannah, Lida, Olive, and Eva, and three of their grandchildren. (North Caldwell Historical Society.)

This photograph shows Grandview Avenue, *c.* 1905. In that year North Caldwell had approximately 85 homesteads and 500 inhabitants. (North Caldwell Historical Society.)

This photograph shows Ethel H. Sanderson (1884–1985) at the fire gong located on Mill Street. She was the daughter of Robert Sanderson and Anna Sindle. Her brother Thomas Sanderson (1887–1950) was a mayor of North Caldwell. Fire gongs were the sole means of sounding a fire alarm prior to the advent of sirens. This gong has been preserved and can be seen across from the police department on Gould Avenue. (North Caldwell Historical Society.)

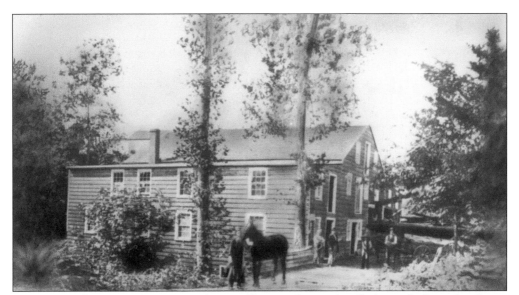

Thomas Sindle operated a grist and sawmill, one of several mills located along the Green Brook. The business was in Sindle's family as far back as 1846. At the mill, logs were made into lumber, and rye, wheat, and corn were ground into grain. The great mill wheel was 18 feet in diameter and 5 feet wide. With the advent of cheap grain and lumber, Sindle was forced to close the mill, which later burned down. It was originally owned by Thomas Spier, Sindle's brother-in-law. (North Caldwell Historical Association.)

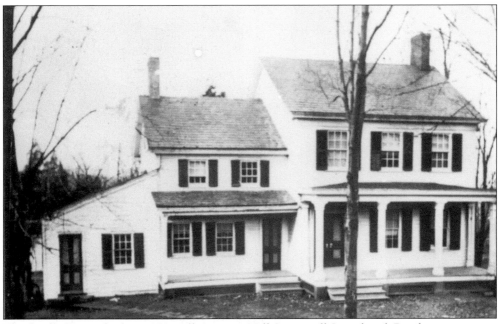

The Sindle House, built *c.* 1850, still exists on Mill Street, off Greenbrook Road.

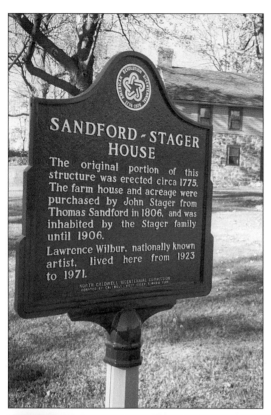

The Sandford-Stager homestead was originally settled by a descendant of Thomas Sandford, who was a Puritan descendant. It consisted of 22 acres with a farmhouse dating back to pre-Revolutionary War days. In 1806, the farm was sold to John Stager and Hendrick Spier Jr. The farm remained in the Stager family for over 100 years. In 1906, the Stagers sold the property to Herman Konig, who immediately transferred the title to Anne Y. Watkins, a relative of Dr. C.G. Watkins of Montclair. Watkins lived in the house with his wife, Jessie Cullen Watkins, for 13 years. During this time, the well-respected artist Ernest Lawson painted a picture of the Watkins Farm (see inside cover). In 1919, Watkins sold the property to J.D. Armitage. Armitage respected the beauty and value of the property and rented it to artist Lawrence L. Wilbur and his wife, who later purchased it from the Armitage estate. The Wilburs raised two sons, one of whom was writer, Pulitzer Prize winner, and poet laureate Richard Wilbur.

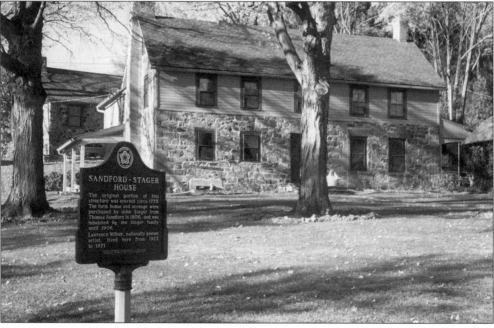

This photograph shows the Gould Avenue schoolhouse. There has always been a school on Gould Avenue in North Caldwell.

This photograph dating from the 1930s shows some North Caldwell elementary school students with musical instruments. (Horseneck Founders.)

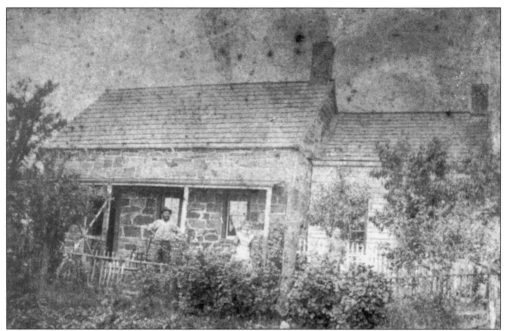

The Bach home, located at 498 Mountain Avenue, was built in 1774, and the date was carved on its cornerstone. The house's original brownstone masonry and beams remain to this day. The Bach family were active in civic affairs and helped to create the first fire department. (North Caldwell Historical Society.)

This photograph shows Robert Sanderson (1856–1939) picking up the mail. Sanderson married Anna Sindle, the boss's daughter at the Sindle Gristmill. His daughter was Ethel, and her son was Thomas. Ethel was a good friend of opera star Madame Ernestine Schumann-Heink, who returned to North Caldwell for the funeral of Ethel's mother. (North Caldwell Historical Society.)

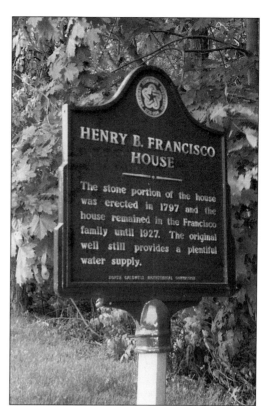

The Henry Francisco house is located at 23 Allen Road, just off of Grandview Avenue. Built in 1797, it is one of three 18th-century homes still standing in North Caldwell.

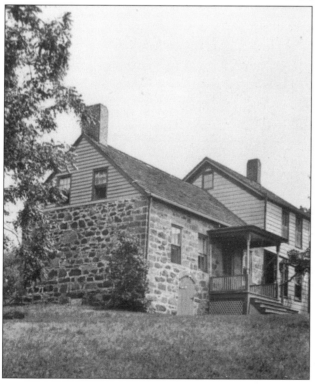

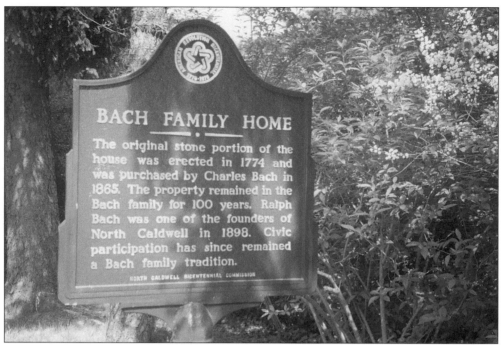

BACH FAMILY HOME

The original stone portion of the house was erected in 1774 and was purchased by Charles Bach in 1865. The property remained in the Bach family for 100 years. Ralph Bach was one of the founders of North Caldwell in 1898. Civic participation has since remained a Bach family tradition.

NORTH CALDWELL BICENTENNIAL COMMISSION

This photograph shows the Bach family home as it exists today on Mountain Avenue in North Caldwell.

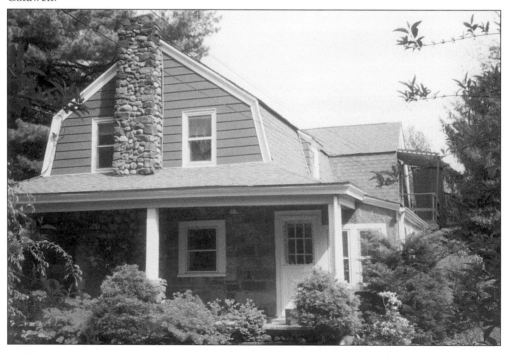

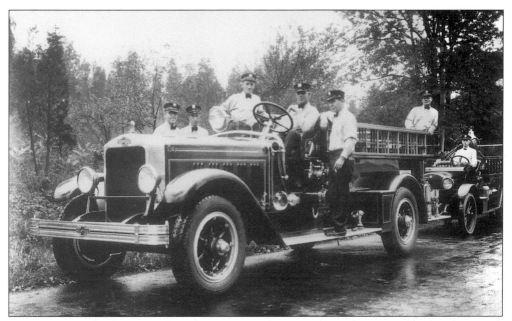

These men were among North Caldwell's firefighters in the early 1930s. To this day North Caldwell continues to have an all-volunteer fire department. (North Caldwell Historical Society.)

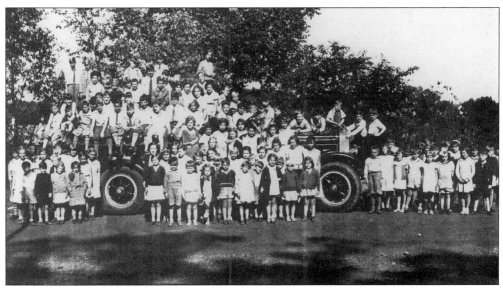

North Caldwell children enjoyed getting up on the local fire engine. (North Caldwell Historical Society.)

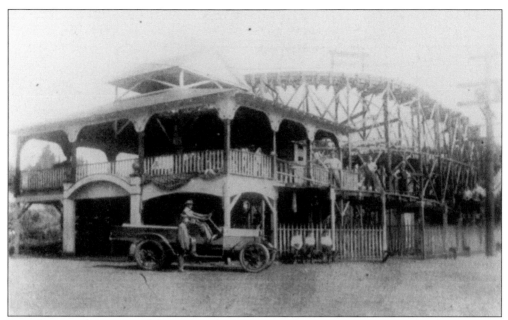

Grandview Park was one of the earliest amusement parks in New Jersey. It opened in the early 1900s at the foot of Grandview Place. The amusement park boasted the usual attractions, plus two Olympic-sized pools, two roller coasters, and an outdoor circus. The main swimming pool, which opened in 1929, accommodated 6,000 bathers and was billed as the largest pool in the state. Many people came to the park from Paterson, traveling via the streetcar that ran down Main Street into Singac. This 1916 scene shows the roller coaster, which burned down in 1935. Shortly thereafter, the park was torn down. (North Caldwell Historical Society.)

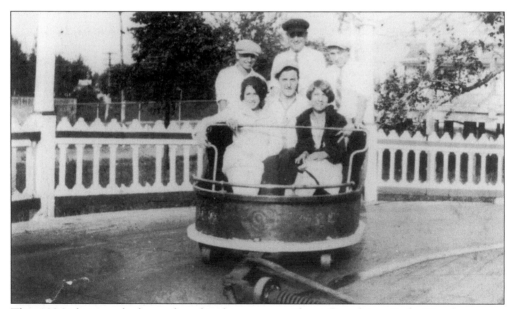

This 1926 photograph shows the whip bumper-car ride at Grandview Park. Out front were Grace DiGiacomo and Josephine Ruffalo. Standing in the rear was Charlie Shew, who ran the kiddie rides. (North Caldwell Historical Association/Grace DiGiacomo Minchin.)

This photograph shows pupils at the Gould Avenue school in the 1930s. (Horseneck Founders.)

In the 1930s, these students attended the Gould Avenue school. Until the Grandview Avenue School was built, all of the borough's elementary schools were located on Gould Avenue. The North Caldwell Police Department is currently located in a former Gould Avenue school. (Horseneck Founders.)

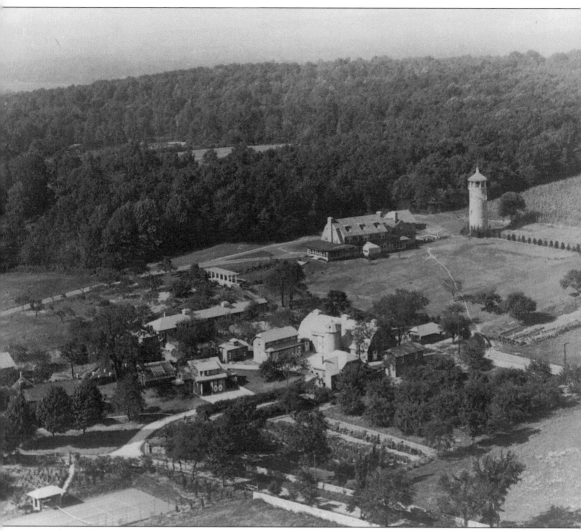

This aerial photograph of the J.D. Armitage estate was taken in 1923. The large house on the property is now 6 Farmstead Road. The intersection of East Greenbrook Road and Mountain Avenue is located just beyond the lower right corner of the photograph. Joshua Dickenson Armitage (1870–1949) came from England as a widower. With the assistance of his secretary, Walter Pidgeon, Armitage purchased a large amount of acreage in his quest to create a country estate modeled on those in his native England. A 1926 map showed the Armitage property to contain a total of 203.56 acres. As part of the estate, Armitage purchased the Sandford-Stager house, and while making a few improvements to it, he rented it out to an artist and his family. (NHHS from the Nash Hanson collection, 1997.)

Before 1930, all police matters in North Caldwell were handled by borough marshals, who were appointed by the mayor. In 1930, an ordinance was passed to create the North Caldwell Police Department. Chief John Masterson became the borough's first chief and stayed on until his retirement in 1941. Sir Robert Peel organized the first regular police force in London in 1829, and five years later a force was created in Philadelphia. Most American cities didn't have regular police forces until the 1840s. (North Caldwell Historical Society.)

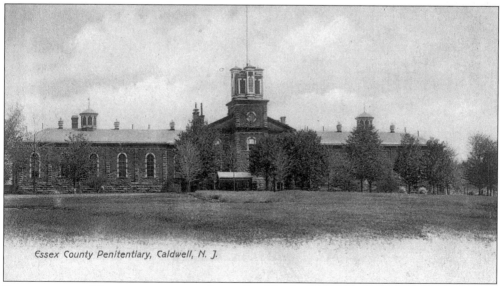

Essex County Penitentiary, Caldwell, N. J.

For many years this county institution located in North Caldwell was known as the Caldwell Penitentiary. Established in 1873, the institution was originally designed for persons convicted of lesser crimes, first offenders, and youthful offenders. In 1920, the number of inmates totaled 261. Most of them were put to work in useful occupations such as farming. For many years the inmates farmed county land and provided county institutions with the harvest.

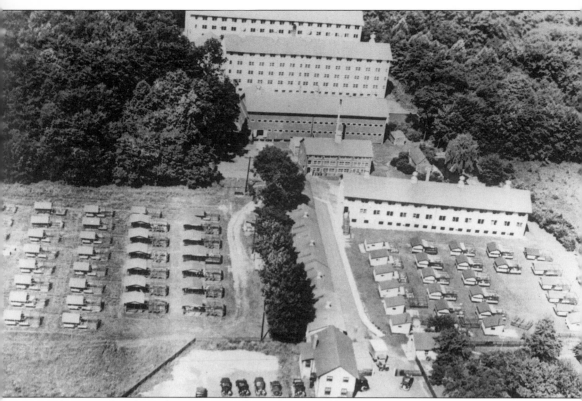

The Greenbrook Poultry Farm was located on Gould Avenue, shown at the bottom of the photograph. The farm was started in the 1920s. This late-1930s aerial photograph is owned by S. Passafaro of North Caldwell, who managed egg production for the farm. The borough's swimming pool now occupies the area of the turkey coops, on the left. Chickens were raised in the remaining buildings. Borough hall now occupies the area of the trees in the right foreground. The farm was known as the "Millionaire's Farm" since it was started and owned by the Dugan Bakery of Newark, New Jersey. According to Mr. Passafaro, the farm had 45,000 laying hens and raised over 250,000 broilers yearly. For years the farm was a favorite field trip for North Caldwell youngsters. (North Caldwell Historical Society.)

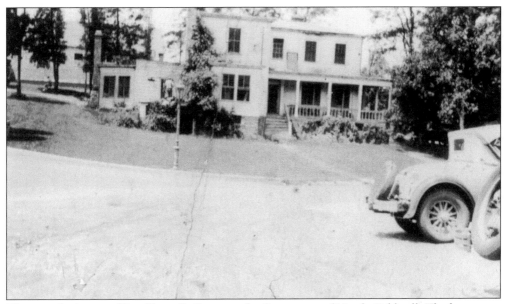

This was the home of Dr. Oliver B. Dawson, the first mayor of North Caldwell. The home was located on the present site of the Greenbrook Country Club. Dawson was a physician who moved to Texas in 1907. (North Caldwell Historical Society.)

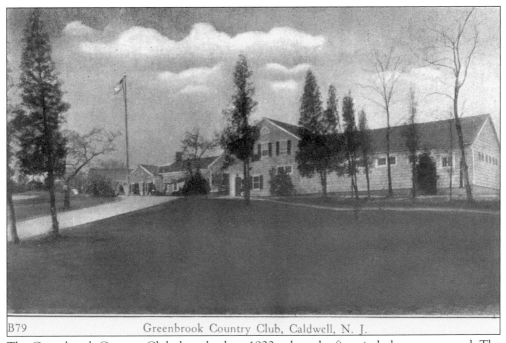

B79 Greenbrook Country Club, Caldwell, N. J.

The Greenbrook Country Club dates back to 1922, when the first six holes were opened. The rest were ready in 1923. To this day, it continues to be one of the finest golf clubs in the area. (Straub Collection.)

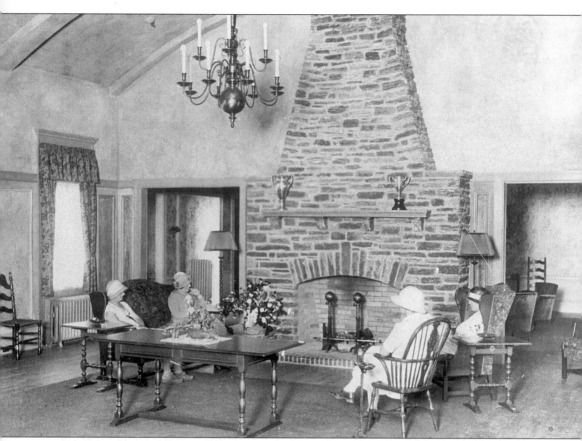

This photograph shows ladies in the early 1930s enjoying the ambiance of the Greenbrook Country Club. The original clubhouse was purchased from Dr. Oliver B. Dawson. (New Jersey Historical Society.)

This postcard shows Mountain Avenue heading into North Caldwell from Caldwell. Out of sight on the right is the Essex County Penitentiary. (Straub Collection.)

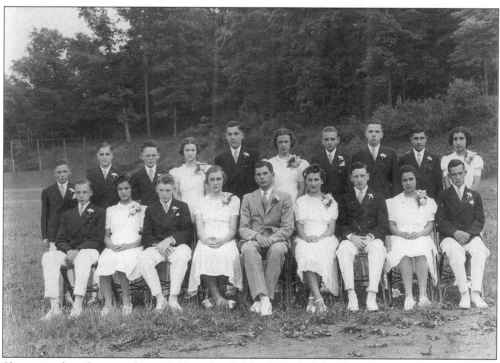

Shown in this photograph, *c.* 1940, is the Caldwell High School graduating class. In the first row, third from left, is Robert Laine Baldwin of North Caldwell. Prior to the formation of the West Essex Regional High School, all high school students from North Caldwell attended Caldwell High School. (Horseneck Founders.)

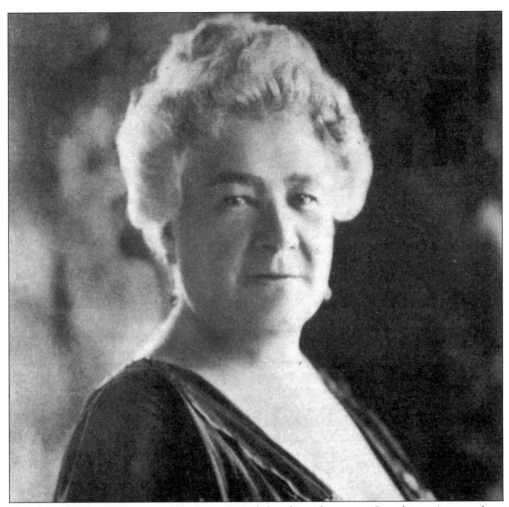

Opera star Madame Ernestine Schumann-Heink lived in a house on Grandview Avenue from 1906 until 1917, besides having homes in New York City and other locales. Born near Prague in 1861, she made her concert debut at age 15 and her opera debut at 17. She was already an international operatic figure before coming to North Caldwell. Besides performing in Berlin and Hamburg, she was the guest artist appearing with the renowned composer and conductor Gustav Mahler at London's Covent Garden. Her name was the reverse of her two first marriages: Paul Schumann, an actor, and Ernest Heink. She came to America in 1898, singing in Chicago and on the stage of the New York Metropolitan Opera House in 1899, where she stayed until 1904. She became an American citizen in 1904. She was married three times and had eight children. Madame Schumann-Heink became a part of the West Essex community. She sent her children to Caldwell High School. She frequently took her team of horses and rode in a wagon to the nearby Van Ness and DeBaun farms in Fairfield for fresh chickens and produce. She is said to have been a demanding patron, requiring the best of everything. The leading contralto of her day, she had a powerful voice which was said to have an "organlike quality." A famous story relates that one night in a concert hall, as Madame Schumann-Heink was struggling to get by between the orchestra and the footlights, a violinist whispered "Sideways, Madame, sideways," to which the famous contralto replied, "Mein Gott! I haff no sideways." Her last appearance at the Met was in 1936 at the age of 71. She died in Hollywood on November 17, 1936.

Even though the home of Madame Schumann-Heink no longer survives, the Grandview Place area shown in this photograph continues to be known as Schumann-Heink Hill after the famed opera diva.

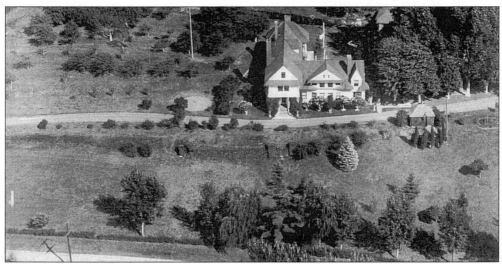

This photograph shows the Grandview Place home of Madame Ernestine Schumann-Heink, who lavishly furnished it and lived here from 1905 to 1917. The mansion she purchased was located on the brow of Kussmaul Hill. It had been built for William Ryle, a wealthy silk manufacturer from Paterson. Ryle and his wife, Susan, moved into the house in 1899 and named it Will-Sue. (Mr. and Mrs. Raymond Dee.)

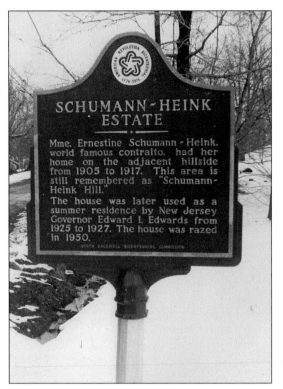

SCHUMANN-HEINK
ESTATE

Mme. Ernestine Schumann-Heink,
world famous contralto, had her
home on the adjacent hillside
from 1905 to 1917. This area is
still remembered as "Schumann-
Heink Hill."

The house was later used as a
summer residence by New Jersey
Governor Edward I. Edwards from
1925 to 1927. The house was razed
in 1950.

NORTH CALDWELL BICENTENNIAL COMMISSION

This photograph shows The Clouds, after it had been the Schumann-Heink estate. The property was situated on 45 acres and later became the home of Edward I. Edwards, who served as a New Jersey governor and a U.S. senator. The house had 15 rooms and a four-car garage. It was listed for sale in the late 1920s for $120,000 and was said to have "a view not excelled by any property in the state." Edwards built a carriage house next door for his daughter Constance, which survives today as the residence of Mr. and Mrs. Raymond Dee. The main house, however, was torn down. (Straub Collection.)

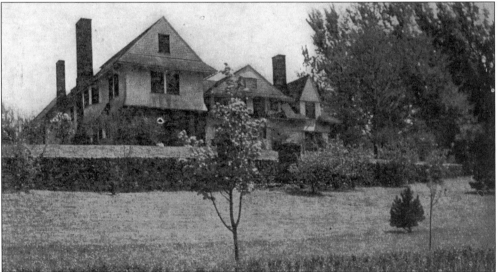

On September 10, 1912, Madame Ernestine Schumann-Heink gave one of two benefit concerts at the First Presbyterian Church in Caldwell. The concert was sold out and the proceeds of $1,125 were donated to the Grover Cleveland Birthplace Memorial Association, formed to preserve the birthplace of the nation's 22nd and 24th president. Later, when the association needed more funds, Mme. Schumann-Heink gave a second recital. (The State of New Jersey, Grover Cleveland Birthplace Historic Site.)

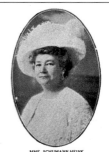

MME. SCHUMANN-HEINK

PROGRAMME

MME. SCHUMANN-HEINK
BENEFIT RECITAL

MRS. KATHERINE HOFFMANN, Accompanist

FIRST PRESBYTERIAN CHURCH
CALDWELL, N. J.

TUESDAY EVE'G, SEPT. 10, 1912

STEINWAY PIANO USED

The committee wishes to express its thanks to the Steinway Company for the use of a piano.

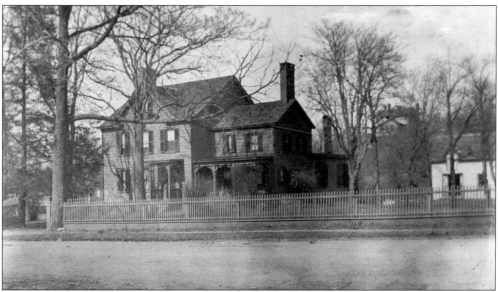

This photograph is of the Old Manse in Caldwell, the birthplace of President Grover Cleveland. Cleveland was born here on March 18, 1837, and was named Stephen Grover Cleveland. His family left Caldwell when he was four years old. It is not known if he ever returned. The Old Manse was also the residence of the pastor of the First Presbyterian Church in Caldwell. This photograph, a gift of Caldwell photographer Gene Collerd, is the oldest known one of Cleveland's birthplace. It shows Bloomfield Avenue as a dirt road. (State of New Jersey, Grover Cleveland Birthplace Historic Site.)

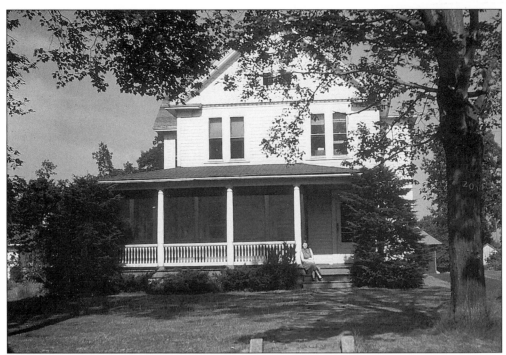

This photograph taken in 1948 shows the Frank H. Baldwin residence, built *c.* 1890. In 1894, the house was hit by lightning, which caused a small fire. In the 1950s a second fire destroyed the porch, which was not replaced. The house was located at 201 Mountain Avenue. (Horseneck Founders.)

Walker's Pond, adjacent to the Walker homestead, provides North Caldwell residents with a Currier and Ives setting for ice-skating during the winter. Shown here in the center are Carlee Walker and her son Christian. The horse belonged to Karen DeCamp and was probably the last one to live in North Caldwell. Also pictured are Sally and Suzy Braddock from Mountain Avenue, and Margot and Gail Williamson from Greenbrook Road. The tractor and trailer are garden equipment belonging to the Walkers, who moved into their just-completed house on January 4, 1950. (Elwood C. Walker.)

This photograph shows Col. Charles A. Lindbergh standing by the *Spirit of St. Louis*, the airplane in which Lindbergh made the first nonstop transatlantic flight in 1927. Lindbergh made several visits to West Essex during his lifetime and was familiar with the airport in Fairfield, where he had one of his planes reconditioned. (Photo Researchers Inc.)

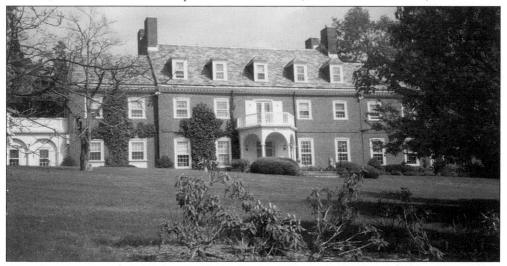

According to rumors circulating in 1929, this magnificent Federalist-style home located on Hamilton Drive West was looked at and considered by Col. Charles A. Lindbergh for a possible residence. There is no doubt that Caldwell Airport (then called Marvin Airport) being only a few minutes away made this a very attractive home for Lindbergh, whose wife's parents lived in Englewood. This house was completed in 1926 and contained 19 rooms and 6 baths. It was originally the home of Alexander H. Sands. Although Lindbergh never purchased the home, the *Caldwell Progress* reported in October of 1929 that Horace C. Sylvester Jr. of Essex Fells, the father of Johnny Sylvester of Babe Ruth fame, had purchased the home at a price speculated to be $100,000.

This 1921 photograph of mothers and babies shows evidence of a small baby boom in North Caldwell. Among those pictured here are baby Betty Baldwin with her mother Ruth Hawley Baldwin (far left), and Frank Alison Baldwin with his mother Kathleen Cavanaugh Baldwin (third from left). (Horseneck Founders.)

Here Personnette G. Baldwin of Mountain Avenue, North Caldwell, third from right, is shown greeting newly returned GI's at Newark Airport during World War II. (Horseneck Founders).

This photograph shows the Francisco house as it appears today.

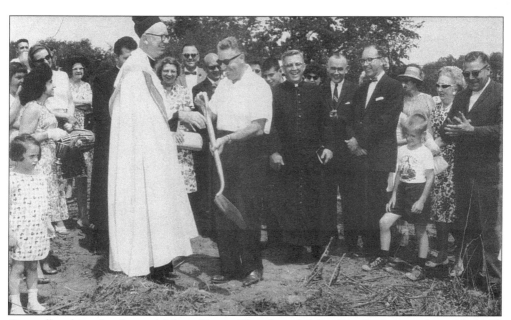

Groundbreaking for the new Notre Dame Church and School took place on June 15, 1964. Father Murphy and a jubilant group of parishioners gathered to break ground at the Central Avenue location. Notre Dame is one of a long line of parishes created from the mother parish of St. Aloysius in Caldwell.

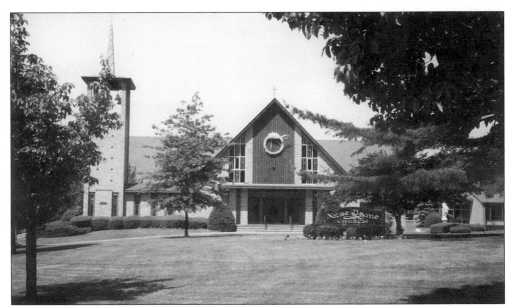

This photograph shows the Notre Dame Church and School, located on Central Avenue, shortly after completion. The school is staffed by the Sisters of St. Joseph of Chestnut Hill, Philadelphia. This order dates back to October 15, 1650, when a group of women embraced the religious habit in the chapel of the orphanage committed to their care in Le Puy in southern France.

This recent photograph shows the West Essex Regional High School. This school first opened for classes in the academic year 1961–62 and brought together students from Essex Fells, Fairfield, North Caldwell, and Roseland.

Four

ROSELAND

After the American Revolution, permanent communities were established by the early settlers. Livingston Township was established in 1813 from a consolidation of seven separate hamlets: Teedtown, now Livingston Center; Squiertown, now West Livingston; Canoe Brook, now Northfield; Cheapside; Washington Place; Morehousetown; and Centreville (known as South Caldwell prior to 1813), now Roseland.

When the citizens of Centreville petitioned the federal government for their own post office, they were urged to change the name since there was already a Centreville post office in Hunterdon County. Research shows that at a meeting held at the white schoolhouse in 1873, Sarah Condit suggested the name of Roselyn (Rose-lyn). This was accepted, and William H. Harrison, the father of Mrs. Percy Teed, became the first postmaster of Roselyn on February 13, 1874. Whether through misspelling or design, the post office name became Roseland on April 14, 1874. In the early 1900s, Roseland, which was still part of Livingston Township, wanted a new school in its locale. When a delegation from Roseland was outvoted in Livingston, momentum sprang up for independence. A petition for a new borough was quickly circulated and presented to the state legislature. On March 10, 1908, Governor Fort signed a bill submitting the question on referendum to the residents of Roseland. The vote for incorporation was 100-0, and on April 10, 1908, the Borough of Roseland came into existence. The first election of the newly incorporated borough was held on April 29, 1908, in Willard "Gus" Osborn's general store, located on the south side of Eagle Rock Avenue, facing Roseland Avenue. The unanimous election resulted in George F. DeCamp as mayor; Henry C. Becker, Willard A. Osborn, Joseph C. Conover, Charles Braunworth, Ezra A. Williams, and Clarence Harrison as councilmen; Joseph H.M. Cook as assessor; Walter Baldwin as tax collector; and Everett Booth as borough clerk, with a salary of $50 per year.

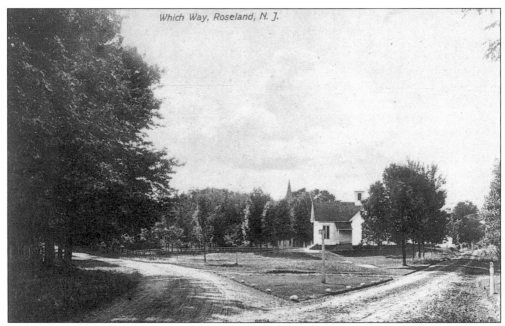

This photograph is one of the earliest pictures of the "point" at the split between Eagle Rock Avenue and Harrison Avenue. The borough's second schoolhouse is the white building. Soldiers trained here regularly from Revolutionary War times to just before the Civil War.

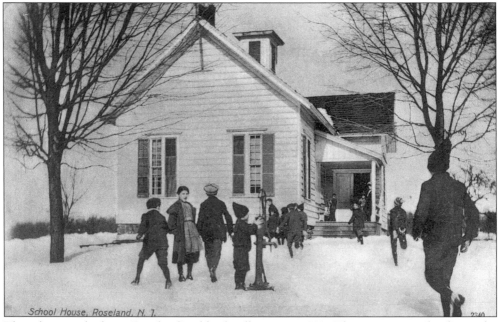

This photograph shows Roseland's old schoolhouse, c. 1899. The two-room school was the second in Roseland's history. A four-room, red brick schoolhouse was dedicated in 1909, and a modern, yellow brick school was erected on Harrison Avenue in 1926. The Lester Noecker School is the present-day elementary school.

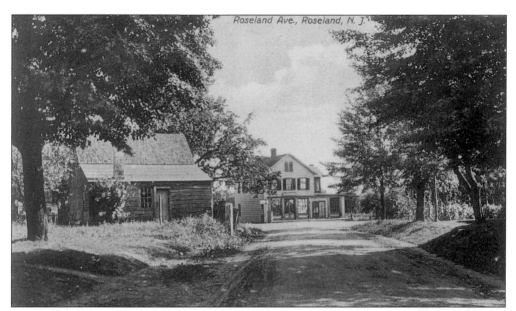

This 19th-century photograph of the intersection of Roseland Avenue and Eagle Rock Avenue shows Osborn's store, the business focal point of the area. It was here that the Borough of Roseland came into being. Today, the intersection has a replica of the building, which is now occupied by Arcadia Real Estate.

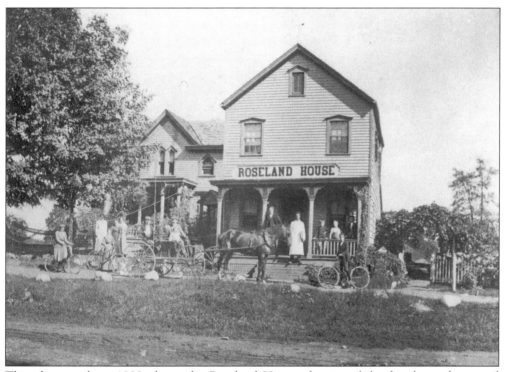

This photograph, c. 1900, shows the Roseland House, the site of the first borough council meetings. Also known as the Temperance Hotel, the building was located on Eagle Rock Avenue, where Roseland Plaza now stands.

This postcard scene from the late 1890s shows Prospect Street as a beautiful country lane. Both the band hall and the grange hall were located on this street. (Straub Collection.)

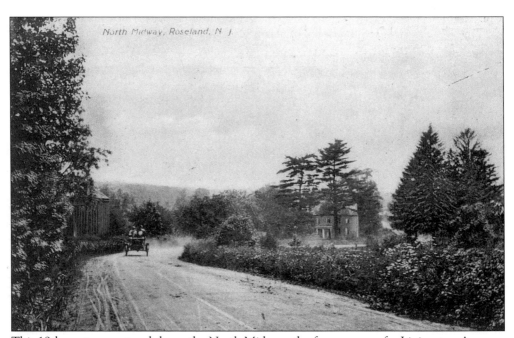

This 19th-century postcard shows the North Midway, the former name for Livingston Avenue. On this road in later years the Becker Dairy Farm was established. (Straub Collection.)

This 19th-century winter scene shows Eagle Rock Avenue, formerly known as Swinefield Road. Swinefield Road was first surveyed in 1705 and again in 1733. In colonial times it served as the way to carry freight between Morris, Warren, and Sussex Counties and Newark. During the American Revolution, it was used by militia and regulars, as well as Tories and irregulars. It was also used several times by General Washington and his officers on several occasions when moving between Morristown and Pompton.

This picture shows the Roseland House after several modifications were made to it. Originally it was Layland's Tavern, the only bar in the village for over a century. When it was sold, the tavern was converted into a temperance house, which took in borders. It was situated where the Roseland Plaza is now.

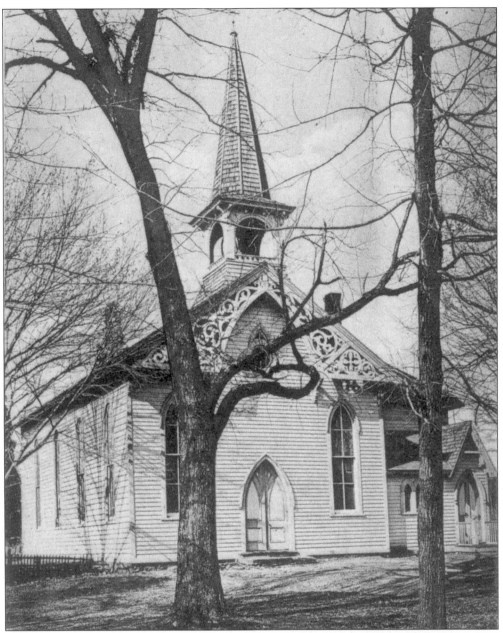

This photograph shows the Methodist church in Roseland as it appeared in 1896. The Methodist movement in the area started in 1822. In 1824, the Methodist Episcopal Church purchased an acre of land for the church at a cost of $25. A new organization called the Methodist Protestant Society took over the church when the congregation of the Methodist Episcopal Church dwindled. In 1878, an addition was built on the church, including a belfry. A church bell was installed in 1890, and a Sunday school room was added in 1895. On April 6, 1903, the name of the church was changed from the Free Methodist Protestant Church of Centreville to the Methodist Protestant Church of Roseland. In 1939, it became simply the Methodist Church. The minister lived in the Manse, a large white house on the site of the current post office, at the corner of Eagle Rock and Roseland Avenues.

For many years the Presbyterians and the Methodists met in one church and held united services. In 1891, the Presbyterians decided to have a church of their own. They established it directly across the street from the Methodist church, on land formerly donated by Mrs. Ira Condit.

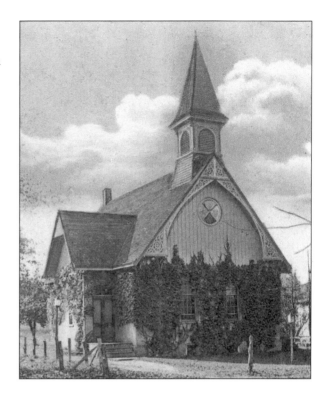

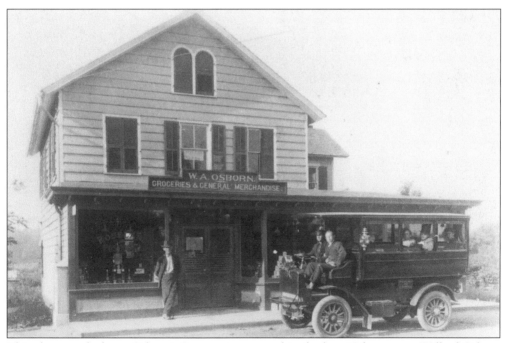

This photograph shows Osborn's Store as it appeared in the late 19th century. Willard Osborn operated the general store, which, besides foodstuffs, sold patent medicine, chicken feed, kerosene, needles and thread, and snuff. Osborn's also housed the post office for several years.

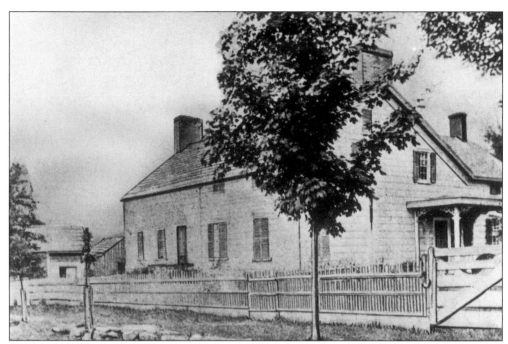

This early photograph shows the Crowl-Harrison house, which was located on Passaic Avenue. The original part of the house was already a century old when Samuel Harrison purchased it in 1810. (Roseland Historical Society.)

This photograph shows horses pulling hay at the Crowl-Harrison farm, c. 1900. This farm is no longer in existence. (Roseland Historical Society.)

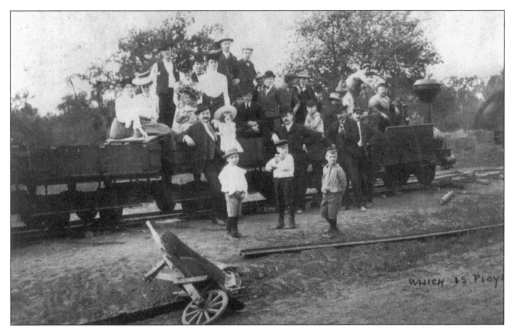

This picture was taken during the construction of the Morristown and Erie Railroad, *c.* 1902–03. The completion of the railroad in 1904–05 connected Morristown and Essex Fells and changed the entire West Essex area. The railroad enabled more people to live in the country and work in the city. Roseland had two stations, one at Harrison Avenue and the other at Beaufort Avenue. Mrs. McEwan, whose family owned a nearby paper mill, chose the name Beaufort. She didn't like the idea of a Swinefield Station, so she suggested Beaufort, after her hometown in North Carolina. (Roseland Historical Society.)

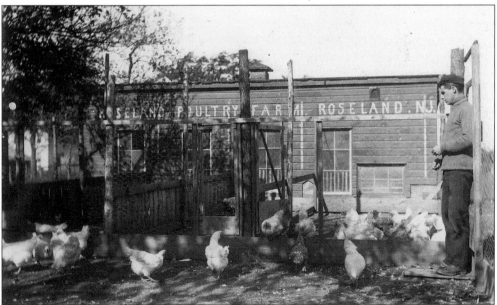

The Roseland Poultry Farm belonged to Caleb Baxter, who served as the mayor of Roseland for a period of time. This photograph shows the farm from Eagle Rock Avenue near Freeman Street, looking south. (Roseland Historical Society.)

Chocktaw Hill was the popular sledding spot in the wintertime. This early-1900s photograph shows the hill, adjacent to Eagle Rock Avenue. Chocktaw Way is now a road that runs through the Becker Farm office development.

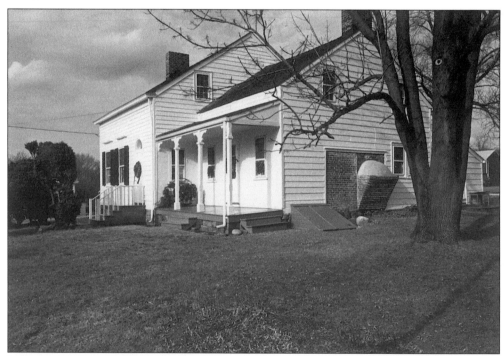

In 1976, the Harrison house served as the headquarters of the Roseland Historical Society. The house was built in 1824 by Amos Williams, a tanner and veteran of the War of 1812. From the house he conducted his tannery business from 1824 to 1865. Williams and his cordwainers made shoes for the Union Army, until the war ended and left him with a large inventory and no more orders. Amos Williams ended up in financial ruin and lost his home. The house was purchased at a sheriff's sale by William Henry Harrison in 1875, with a high bid of $980.

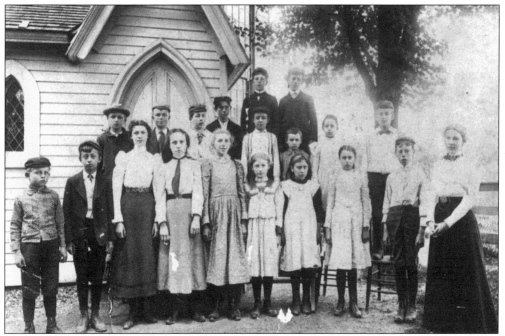

This picture shows Sunday school at the Methodist church in 1890.

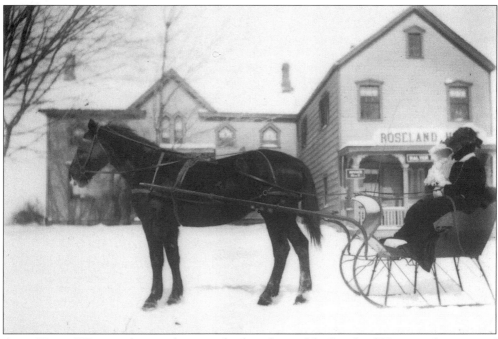

Anna "Brittie" Force is shown riding in a sleigh in front of the Roseland House in the winter of 1910. Brittie, a spinster, lived in the Bond-Force house, which became the Hillside Cottage, a boardinghouse for gentlemen who were seasonal workers. Her brother, who lived with her, ran a kennel at the same location. (Roseland Historical Society.)

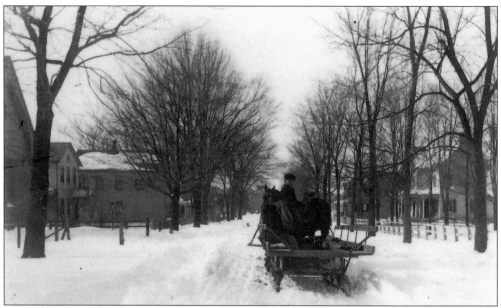

This early-1900s photograph shows Eagle Rock Avenue, with the Presbyterian church on the left and the Meeker house on the right. Swinefield Road, the name for today's Eagle Rock Avenue, has an interesting etymology. This name stems from the early summer custom of driving herds of pigs from West Orange over the mountains along the old trail to the fields near the Passaic River. There, the pigs were left to fatten up on the lush vegetation before becoming bacon, ham, lard, and pork chops in the autumn. It is said that, as a bonus, the swine helped eliminate the rattlesnake population in Hatfield Swamp, adjacent to the river. Swinefield became the name of this pig-fattening area, and the road to it became Swinefield Road. (Roseland Historical Society.)

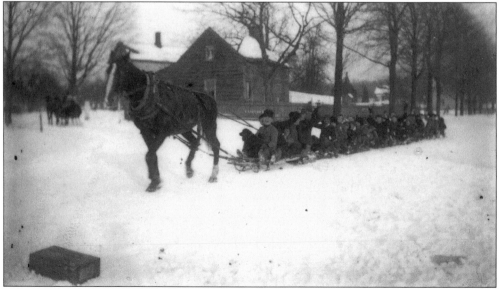

This early-1900s photograph shows Roseland and Eagle Rock Avenues to be a winter wonderland. (Roseland Historical Society.)

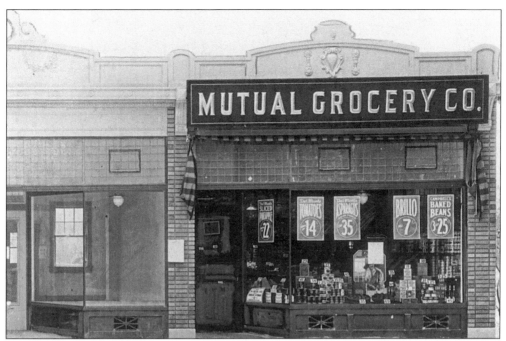

In the early 1900s, the Mutual Grocery Company was located on Eagle Rock Avenue in the building adjacent to the site of the Fairchild Market of today. (Roseland Historical Society.)

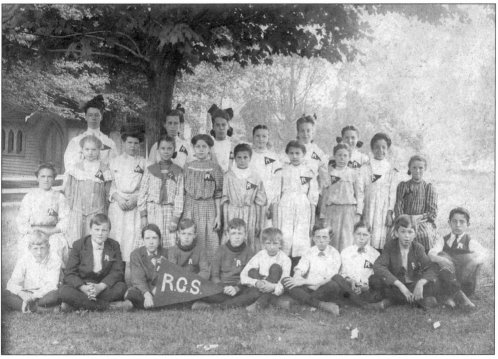

This late-1890s photograph shows what was probably the graduating class at the Roseland Grade School. (Robert Bush Collection.)

For more than 200 years, the Bond-Force house has been occupied by the Bonds, the Forces, and the Grants. Reilly Bond, one of the original owners, was a whiskey distributor, as well as a devout Presbyterian. In 1815, the house was transferred from the Bonds to John Force. It remained in the Force family for many years. Andrew Force was one of the residents who voted for Roseland's independence in 1908. The house, located at 88 Eagle Rock Avenue, still has some original clapboards that date from 1760. The rest of the house dates from 1834. (Roseland Historical Society.)

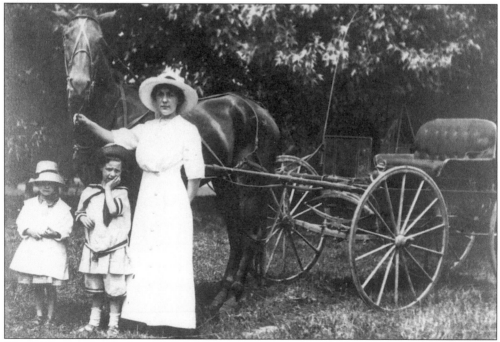

This 1913 photograph shows Gertrude Laura Teed, eldest child of William Henry and Harriet A. Harrison, with her two eldest children, Harriet Louise and Arthur Harrison. (Roseland Historical Society.)

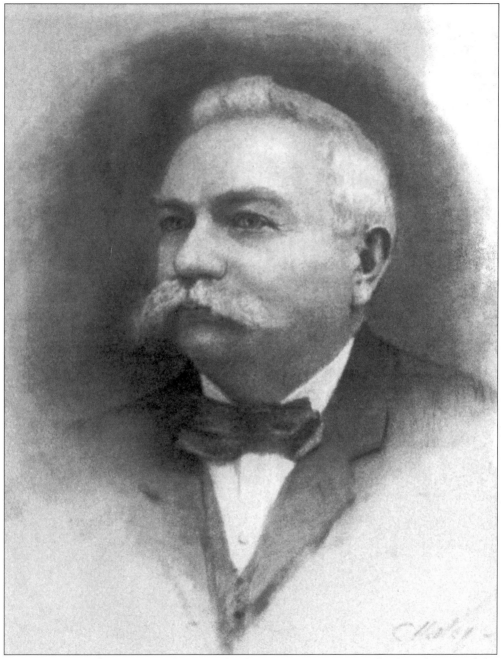

On April 10, 1908, the Borough of Roseland came into existence. The first election of the newly incorporated borough was held on April 29, 1908, in Willard "Gus" Osborn's general store. George F. DeCamp, pictured above, was elected mayor. (Roseland Historical Society.)

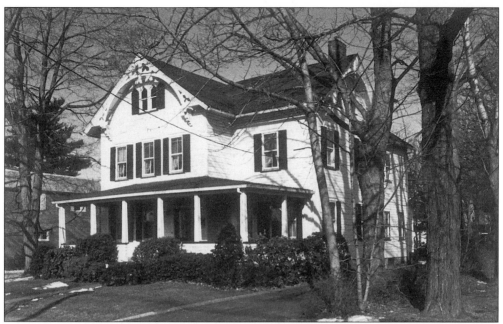

This photograph shows the Peter Meeker house, located near the Methodist church on Eagle Rock Avenue. Meeker was a wheelwright. A barn was located at the rear of the property.

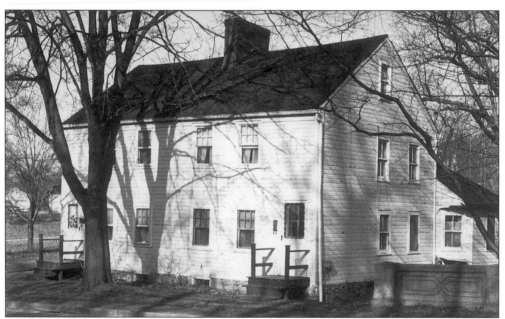

John Beam was born in his father's cabin in Caldwell in 1848 and moved to the Beam homestead in Centreville in 1858. When his brother George enlisted in the Civil War, John Beam begged his father for permission to also join. He was turned down, however, because of his age. Beam learned the shoemaking trade and made shoes for the army during the Civil War. The Beam house, located on Eagle Rock Avenue, was built in 1819. Some say the house was part of New Jersey's Underground Railroad, which helped slaves from the South reach the North.

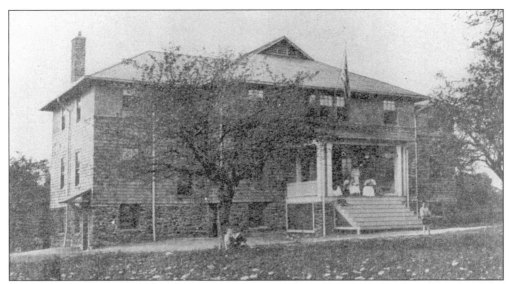

The photograph above shows the Essex County Christian Endeavor Fresh Air Home called "New Fernwood." Through this facility, inner city needy children were brought to Roseland for fresh air. The building later became part of the Fernwood Golf and Pool Club. (Newark Public Library.)

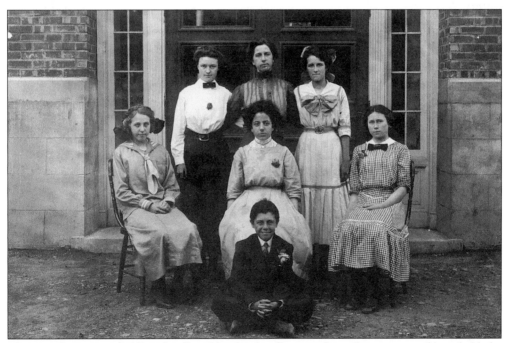

These students attended Roseland's red brick schoolhouse, where they were taught probably by Agnes Kirby. The Kirby sisters taught school in Roseland for several years. This four-room schoolhouse was dedicated in 1909. A modern yellow brick building was built on Harrison Avenue in 1929. (Robert Bush Collection.)

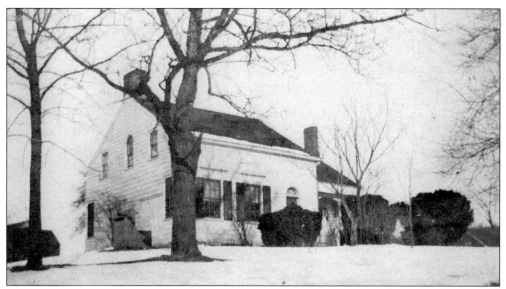

This photograph, c. 1895, is the oldest one in existence of the Harrison House on Eagle Rock Avenue. The house is a fine example of a northern New Jersey homestead of the Federal period. It is listed in the Historic American Buildings Survey and in both the National and the State Registers of Historic Places. In 1976, it was purchased by the Roseland Historical Society, whose purpose is to encourage an appreciation of Roseland history and to preserve its rich heritage. (Robert Bush Collection.)

This photograph, c. 1900, shows the Broemel House, located on Roseland Avenue. The house is now the Farmer Funeral Home. (Roseland Historical Society.)

This photograph, c. early 1900s, shows a card party in progress at what is probably the Harrison House. The gentleman on the far left is Ernest Youngman, a partner in the plumbing firm of Straub and Youngman. Wallace A. Bush and Oscar DeCamp are the third and fourth men from the left, respectively. Lottie Grannis is the second woman from the left, and Mrs. Wallace A. Bush is at the far right. The other persons are unidentified. (Robert Bush Collection.)

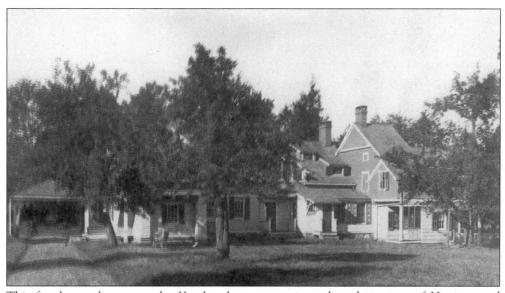

This farmhouse, known as the Keasbey house, was situated at the corner of Harrison and Roseland Avenues, the location of the present Roseland Public Library. Eugene Underhill was one of the owners. He made additions that transformed the simple farmhouse into an impressive home. (Roseland Historical Society.)

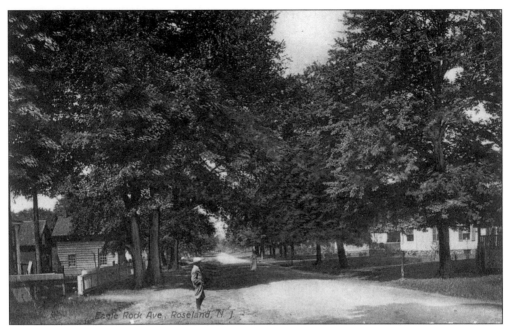

This postcard, dating from the early 1900s, shows Eagle Rock Avenue as a country lane. Today, the road is heavily trafficked. (Straub Collection.)

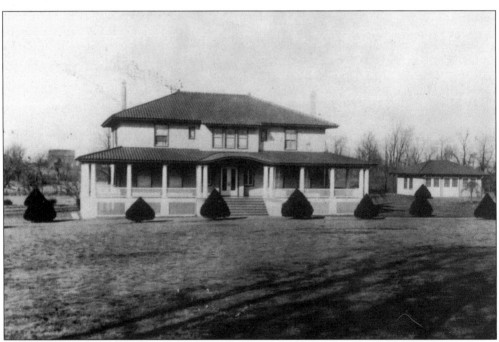

This photograph, c. 1900, shows the Italianesque villa–like home of Count Morissini. The home was located on Harrison Avenue, just west of Roseland Avenue. Although the house is well remembered, little is known about Count Morissini, except that he wore a lot of jewelry with large stones. The site is now the Evergreen Place Development. (Roseland Historical Society.)

Mrs. Wallace A. Bush, a Roseland resident, is shown decked out in golfing attire, heading for the course at the Essex Fells Country Club. This photograph was taken in 1916. (Robert Bush Collection.)

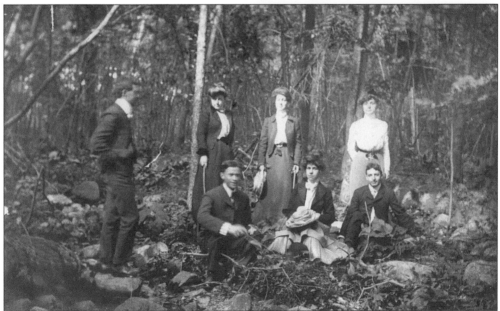

This photograph, c. early 1900s, shows a Victorian picnic under way at a bucolic location near a brook at the Essex Fells border. The three women standing are, from left to right, Bess Teed, Sara Harrison, and Gertrude Harrison. The woman seated is Claribel Harrison. The two men seated are, from left to right, Louis A. Captain and Percy Teed. The man standing is unidentified. (Robert Bush Collection.)

This photograph from the early 1900s shows the Roseland Grade School class with longtime teacher Florence Kirby, standing in the back. The red brick schoolhouse was opened in 1909, replacing the wooden schoolhouse, which was moved and became the Band Hall on Freeman Street.

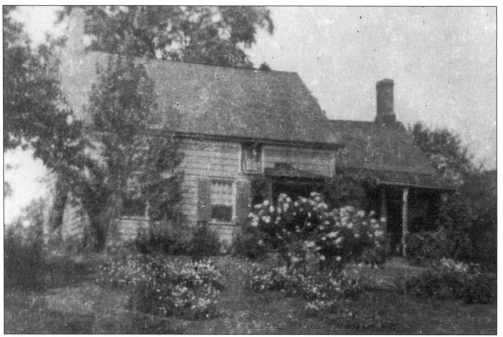

This photograph shows the Henning house, located on Harrison Avenue. The house, now with dormers, is occupied by a local business.

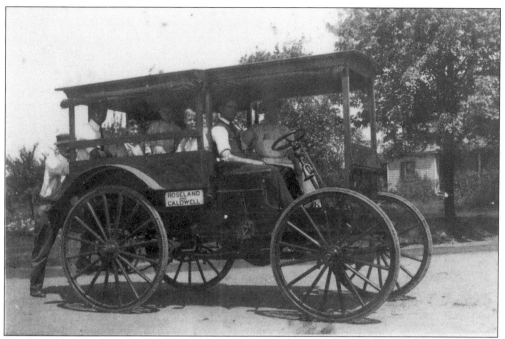

An early form of transportation consisted of this jitney, being driven by Percy Williams on a run between Roseland and Caldwell. (Roseland Historical Society.)

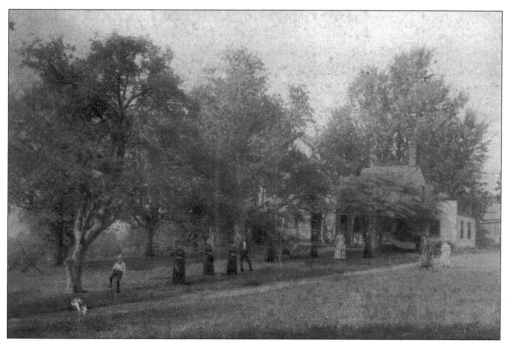

This 1800s photograph of the Bond-Force house shows family members and friends ready for good old-fashioned summer recreation. The children have a bicycle and are ready for tennis and baseball, and everyone is in proper attire. Note the barn in the back, which is not seen in more recent photographs. (Jack Gordon, Esq.)

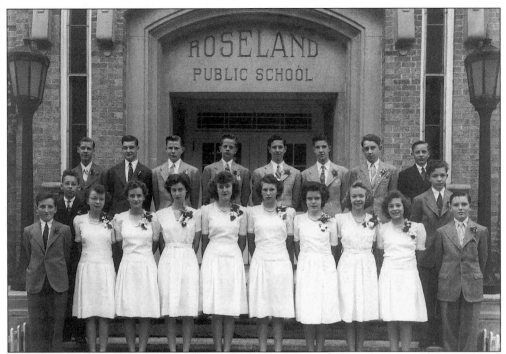

The desire to have a local school system was the driving force behind Centreville's breaking from Livingston and becoming independent. Eventually, overflow conditions at the elementary school forced students to meet at the Band Hall on Freeman Street and Grange Hall on Park Street. Finally, in 1925, a new building was erected. It was later named the Harrison Avenue School. In the early 1900s, Roseland students attended Livingston schools but changed to Caldwell *c.* 1910. In 1961, Roseland joined Fairfield, Essex Fells, and North Caldwell in sending its high school students to the West Essex Regional High School in North Caldwell. Students shown in this photograph were in the Class of 1938–40.

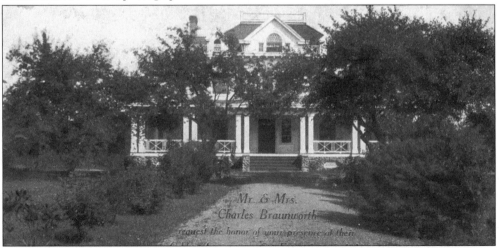

This was an invitation to the 50th wedding anniversary of Mr. and Mrs. Charles Braunworth. The celebration was held June 5, 1920, at the Braunworth's Roseland estate, located on South Livingston Avenue. Today, the home is the convent next to the Blessed Sacrament Church. (Roseland Historical Society.)

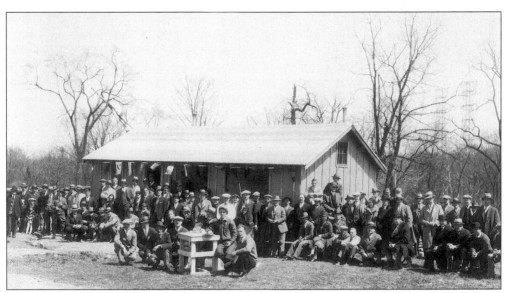

This 1930 photograph shows members of the Roseland Gun Club near their range, which is currently the site of flag maker Annin & Company's corporate headquarters building. (Roseland Historical Society.)

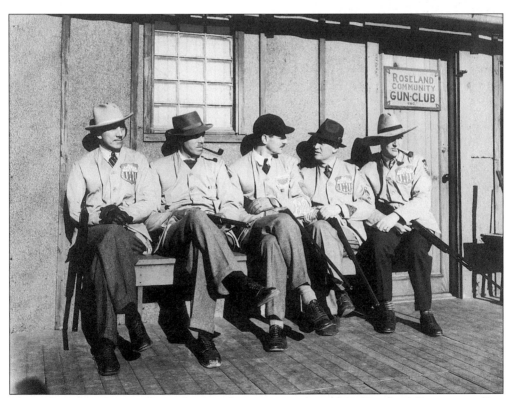

The men in this photograph are the five champion members of the Roseland Community Gun Club. They are shown sitting on a bench, wearing world champion skeet-shooting emblems. (Roseland Historical Society.)

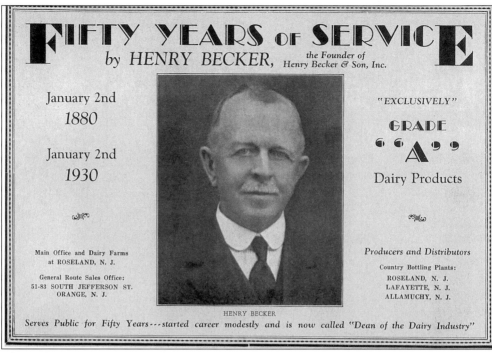

FIFTY YEARS of SERVICE
by HENRY BECKER, *the Founder of Henry Becker & Son, Inc.*

January 2nd
1880

January 2nd
1930

Main Office and Dairy Farms
at ROSELAND, N. J.

General Route Sales Office:
51-83 SOUTH JEFFERSON ST.
ORANGE, N. J.

"EXCLUSIVELY"
GRADE
"A"
Dairy Products

Producers and Distributors

Country Bottling Plants:
ROSELAND, N. J.
LAFAYETTE, N. J.
ALLAMUCHY, N. J.

HENRY BECKER

Serves Public for Fifty Years --- started career modestly and is now called "Dean of the Dairy Industry"

This cover page is from a booklet celebrating the 50th anniversary of Henry Becker's dairy business. Becker was born in 1862 on the family farm on North Midway in Centreville. His father, August Becker, arrived here from Germany in 1848 and acquired a 50-acre farm in 1860. Over the years, members of the Becker family acquired additional land to add to the farm, which at one point covered 1,200 acres—slightly over half the area of Roseland. At the age of 17, Henry Becker set out on a milk route. For the next 29 years, he drove his milk wagon over the mountain to the Oranges and back. Through his hardworking efforts, the Becker Dairy Farm became one of the largest, exclusively Grade A-milk companies in the eastern states. His son Floyd and grandson H. Eugene carried on the business until the property was sold.

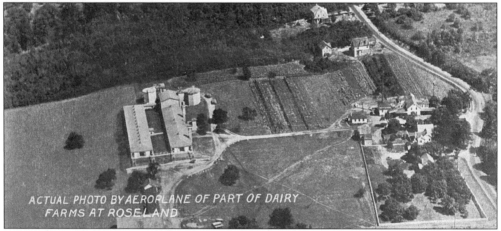

ACTUAL PHOTO BY AEROPLANE OF PART OF DAIRY FARMS AT ROSELAND

This aerial photograph shows a portion of what was Becker's Dairy Farm. The farmland has now been developed as an office complex, except for the 3.5 acres which hold the 1893 Becker farmhouse, barn, and garage—all of which were donated by Mr. and Mrs. H. Eugene Becker to the Roseland Historical Society.

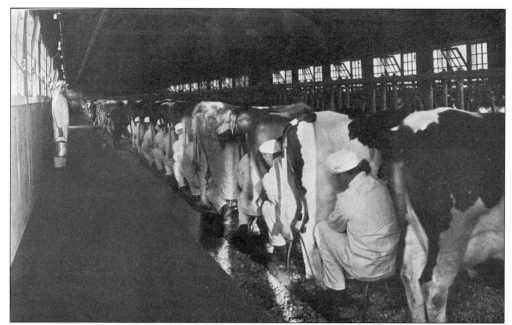

The caption from Becker's Dairy Farm brochure, accompanying this picture, stated the following: "Floors are kept spotless 24 hours of the day. No talking or loud noise [is] allowed in our cow barns at any time. Twice daily previous to each milking the rear three-quarters of each cow is washed with clean, warm water and Ivory soap, then rubbed dry. Windows are so arranged that the bright sunshine floods in directly on all the cows at different periods of the day."

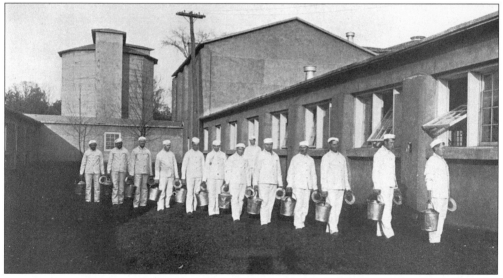

In order to promote its milk, Becker's Dairy Farm emphasized cleanliness. A caption from the dairy's anniversary book stated: "Waiting for the gong to sound, the regular daily routine march of "the Milky Wayfarer." Here are the milkers—clean, white milking suits washed daily. Hands washed before milking each cow; fingernails cleaned daily before each milking. Every man's blood is tested and examined each month by a reputable medical physician. Every man must have the best of health or he is not retained as a Becker dairyman."

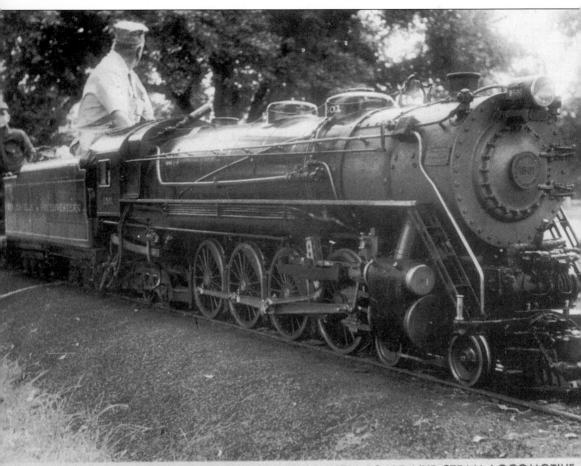

CENTERVILLE & SOUTHWESTERN RAILROAD, 2 INCH SCALE LIVE STEAM LOCOMOTIVE
On the BECKER DAIRY FARM at Roseland, New Jersey

The Becker family's love of trains led to the construction of what was later referred to as one of the greatest miniature trains in the world: a 2-inch-scale railway system (about 1/6 the size of an actual train). Construction began in 1938 on the Becker farm, with the farm laborers performing most of the work. The line was named the Centerville & Southwestern Railroad, after Roseland's original name and the track's general direction, which led to the southwest. A steam locomotive was built by Hobart B. Ayers, a retired president of H.K. Porter Locomotive Company of Pittsburgh. Flatcars were built by Berthed Audsley, a noted model builder. The engine was given the number 1501, after one of the Delaware, Lackawanna & Western "Poconos." The maiden run was in June 1940. Present at the inception was John Draney, famous for his 400-mile run alongside the train that carried doctors to President McKinley, who had just been shot. That 1901 run was from Hoboken, New Jersey, to Buffalo, New York. At the Becker farm, Draney took off in Engine 1501 so fast that the train engineers had to pull the air on him. Draney was quoted as saying that the engine rode so smoothly he felt no danger. The train was simply a hobby at that point. On July 31, 1948, the first paying passengers were carried. Along with engine 1501, there was a diesel engine as a standby. The miniature train generally operated from the middle of May to sometime in October. It drew thousands of visitors from the metropolitan area—and not just children: surviving statistics show that over 40 percent of the train riders were adults.

126

 DAIRY FARMS
ROSELAND, N. J.

Centerville & Southwestern R. R.

Block Signal and
Automatic Air Brake Protection

MAY 11 Through OCTOBER 12, 1963

SATURDAYS: 10 A.M. Through 12 Noon — 1:30 P.M. Through 5 P.M.

MAY 30, JULY 4, LABOR DAY & COLUMBUS DAY

10 A.M. Through 12 Noon — 1:15 P.M. Through 5 P.M.
Trains leave Promptly on the Hour, Quarter Hour, and Half Hour.

WEDNESDAYS: July and August Only

1:30 P.M. Thru 4:30 P.M. & 6 P.M. to Sunset (Almanac Time)

ROUND TRIP - 2 MILES

CHILDREN under 12 yrs. 20c - Over 12 yrs. & **ADULTS** 40c

All Schedules subject to change without notice

(SEE MAP ON OTHER SIDE)

From the last day of July 1948 and for nine years thereafter, Pauline (Mrs. Henry E.) Becker ran the ticket office, which included manipulating air valves to raise and lower the crossing gates. According to Gene Becker, the train almost always used a full crew of engineer, firearm, brakeman, and conductor. The train followed its schedule religiously, and many passengers who wanted to take the 10:30 trip but arrived five minutes late had to take the next train. The Becker farm did not charge admission, and Gene Becker recalled that many visitors spent hours just watching the trains or looking at the farm.

Land taxes became prohibitive when the Beckers lost their farm assessment, and Labor Day 1972 was the last run of the miniature train. On that day, 13 trips were made for the 1501 and 11 for the 1502. From 10 a.m. until 5:16 p.m., some 1,800 passengers were carried, most of whom were carried on the steam train.

What became of engine 1501? It had served the Becker farm faithfully for 25 years and had clocked more than 15,000 miles according to its odometer. The Beckers was a final resting place for their most special engine, and on June 27, 1973, engine 1501 was shipped by truck to Dearborn, Michigan, where it was installed in a glass case at the Henry Ford Museum in Greenfield Village. A recent inquiry by the author has determined that the little engine is no longer at the Ford Museum and its whereabouts are unknown at this time.

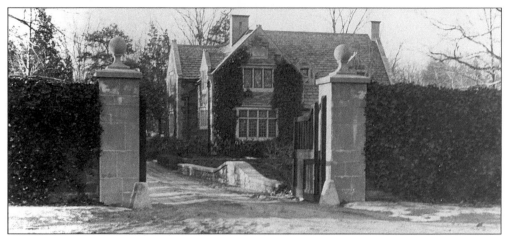

Frank R. Ford Jr. of New York City, an industrial engineer in the metropolitan firm of Ford & Bacon, commenced in the early 1900s to build a magnificent estate called Holmehill. After acquiring over 600 acres, Ford wanted to build a mansion on the highest point, with views east, south, and west. Shown in this photograph is the main gate and gate house. Stones for the wall all came from glacial boulders found on the property. They were cut and fitted by expert stonecutters brought from Italy. After the gate house was completed and before construction of the 16-bedroom main house, Ford's wife died. Ford remarried, and his second wife preferred the excitement of New York City to the wilds of Roseland. So, the Ford estate was never completed, but the Holmehill section of Roseland remains his legacy.

After the chestnut blight of 1915, Frank R. Ford Jr. built this fine chestnut-log cabin at Holmehill. It had large plank floors, a Franklin stove, a huge sunken fireplace, and a bell tower on the roof. Ford used the cabin as a hunting lodge for his family and his customers. Ford's four children from his first marriage also used it as a vacation home and summer residence. (William B. Pryor.)